MAKE
COLOR WORK
FOR YOU

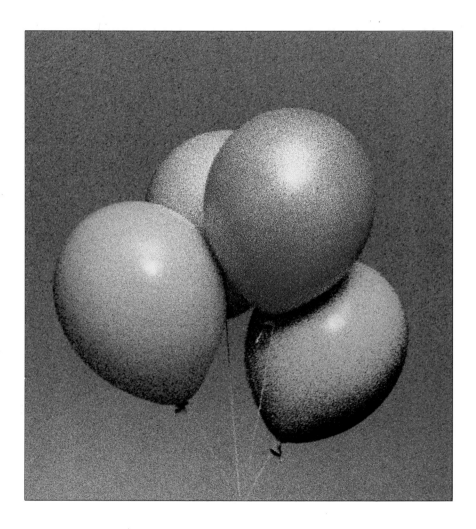

MAKE
COLOR WORK
FOR YOU

Published by Time-Life Books in association with Kodak

MAKE COLOR WORK FOR YOU

Created and designed by Mitchell Beazley International
in association with Kodak and TIME-LIFE BOOKS

Editor-in-Chief
Jack Tresidder

Series Editor
John Roberts

Art Editor
Mel Petersen

Editors
Ian Chilvers
Louise Earwaker
Lucy Lidell
Richard Platt

Designers
Robert Lamb
Lisa Tai

Picture Researchers
Brigitte Arora
Nicky Hughes

Editorial Assistant
Margaret Little

Production
Peter Phillips
Jean Rigby

Consulting Photography
Michael Freeman

Coordinating Editors for Kodak
Kenneth Lassiter
Kenneth Oberg
Jacalyn Salitan

Consulting Editor for Time-Life Books
Thomas Dickey

Published in the United States
and Canada by TIME-LIFE BOOKS

President
Reginald K. Brack Jr.

Editor
George Constable

The KODAK Library of Creative Photography
© Kodak Limited All rights reserved

Make Color Work For You
© Kodak Limited, Mitchell Beazley Publishers,
Salvat Editores, S.A., 1983

Library of Congress catalog card number 82-629-74
ISBN 0-86706-203-7
LSB 73 20L 02
ISBN 0-86706-205-3 (retail)

Contents

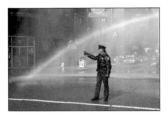

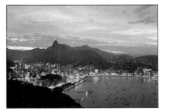

THE MAGIC
OF COLOR

Colors can be breathtaking when their impact is concentrated within the frame of a photograph — deep and resonant reds, subtly modulated greens, singing yellows, solemn or brilliant blues. Although the foundations and traditions of photography were laid in black and white, few photographers today can resist the power of color to evoke excitement, impact, variety — and simply to delight the eye.

There is, of course, a whole range of photographs in which color may be no more than an incidental element, subsidiary to the main point — which may be to record an event, or an aspect of human behavior, or the expression on a single face. However, this book explores something different — the way you can make color itself the subject of the picture by using it purposefully rather than incidentally. Developing this ability to use color creatively can be an absorbing adventure, which may change your whole attitude to color and make you aware that its influence is emotional as well as visual. Color has its own eloquence. The pictures on the following eleven pages work as they do because color is the essential element. Imagine, as you turn the pages, how much would be lost if the images were in black and white. This is the magic of color.

Autumn colors billow in a soft wave over the little girl playing in a park. The picture's charm stems largely from the photographer's decision to allow the beauty of the tree's colors to fill most of the frame.

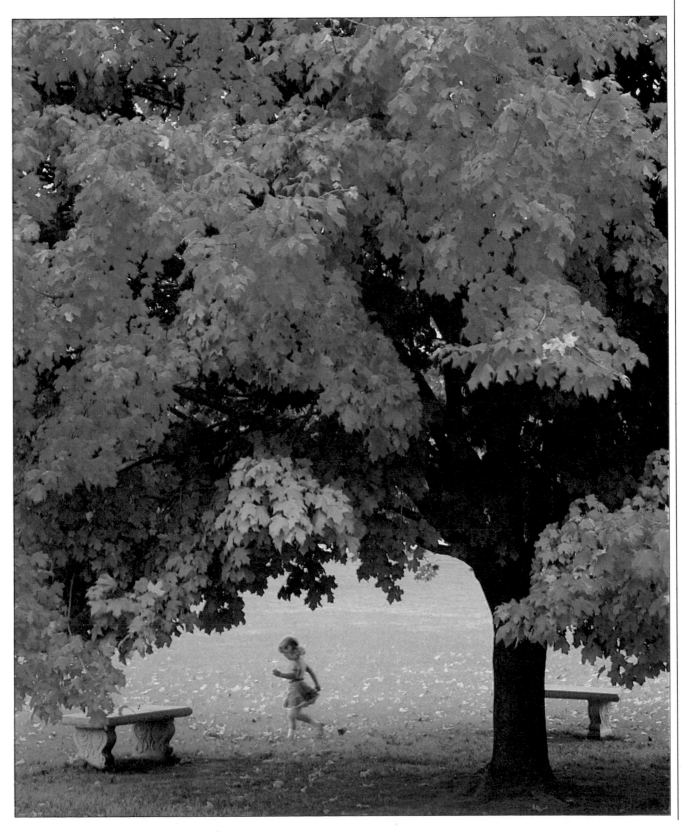

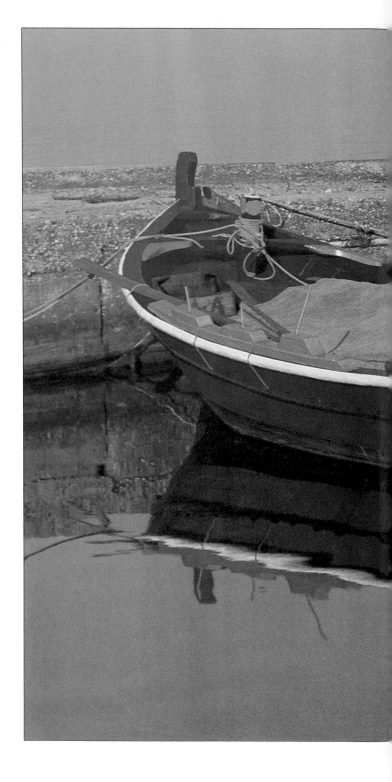

Red boat, blue water, *join in a curve of richly saturated color. Such images speak to us simply. The photographer needed only to spot the freshly painted boat and frame it closely to relate the strong red to the blue of the sky reflected in the clear water.*

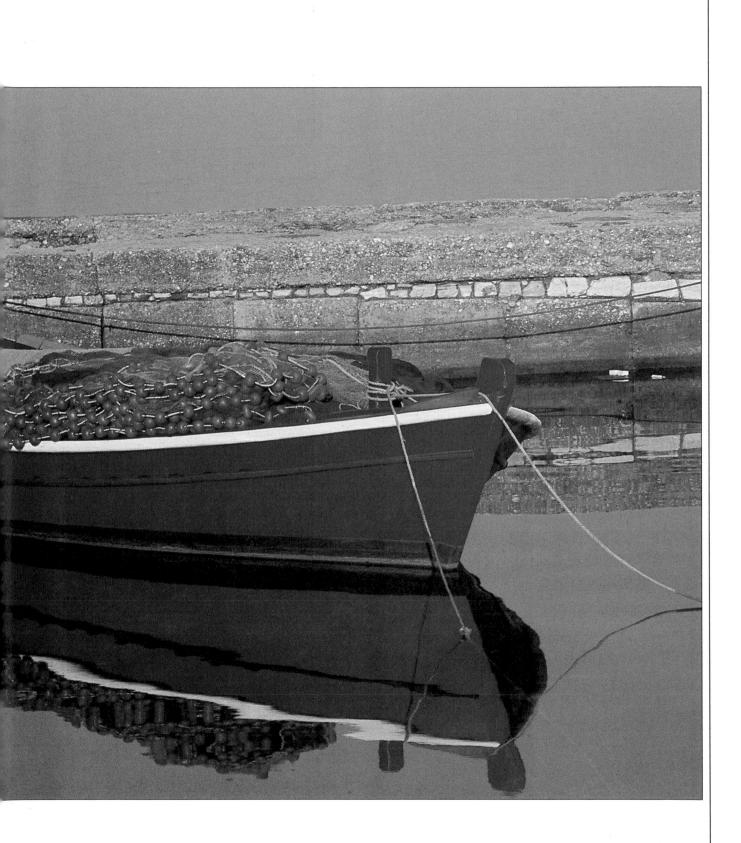

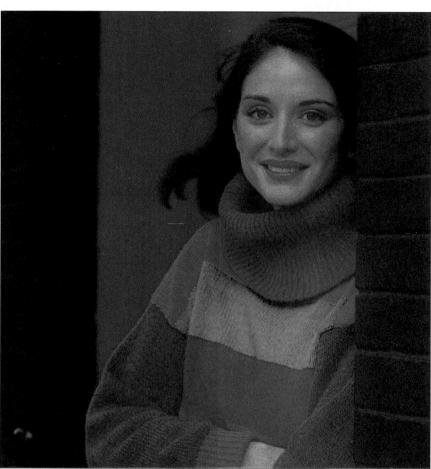

The beauty of a woman,
her smile, and her patterned
sweater are brought out by
a setting that reveals the
photographer's eye for the
way colors work together.
The vivid red background
and the frame of dark bricks
complement perfectly the
subtle hues of the sweater.

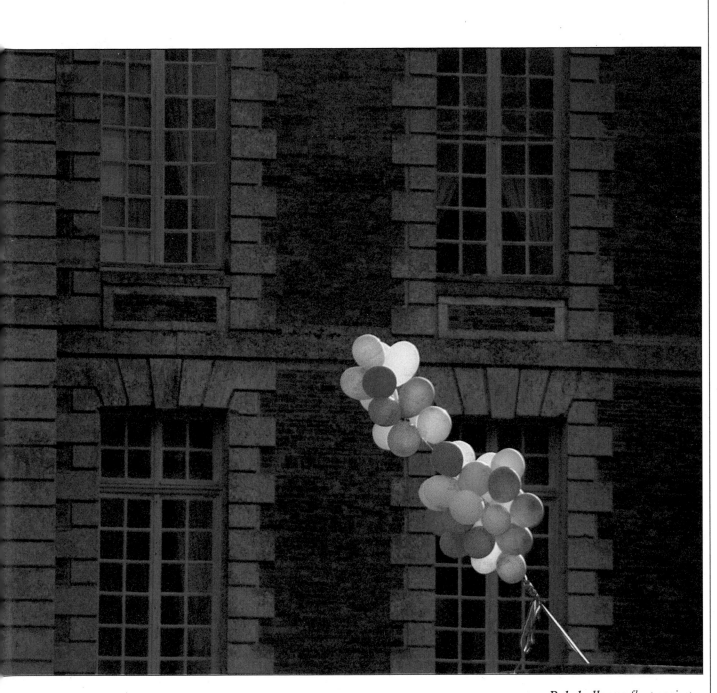

Pale balloons *float against a somber background of shadowed architecture in a composition that deliberately restricts color to a small area of the frame. The surprising impact of the picture demonstrates the power of color to sway us with the lightest touch.*

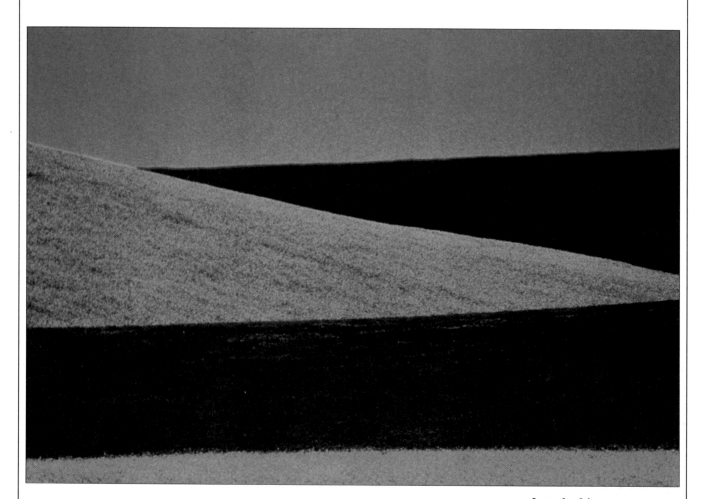

Interlocking segments *of solid color turn a hillside into an abstract pattern that suggests the strength of the landscape itself. The picture has been carefully exposed and printed to heighten the contrasting tones of the sky and hill against the thin yellow line of crops.*

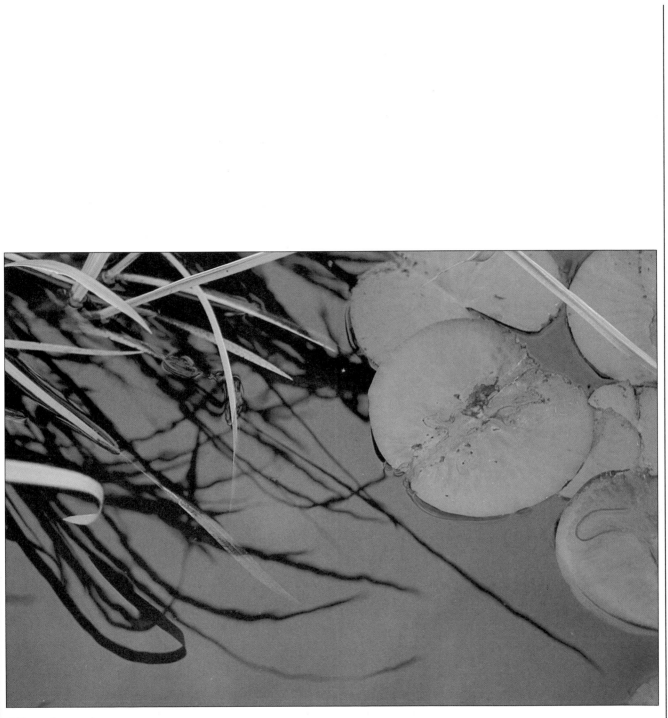

Lily pads, *curving grasses, and the glassy surface of a pond create cool color harmonies that only an observant eye might notice. By moving in close, you can often discover such hidden beauty in nature and isolate it in pictures.*

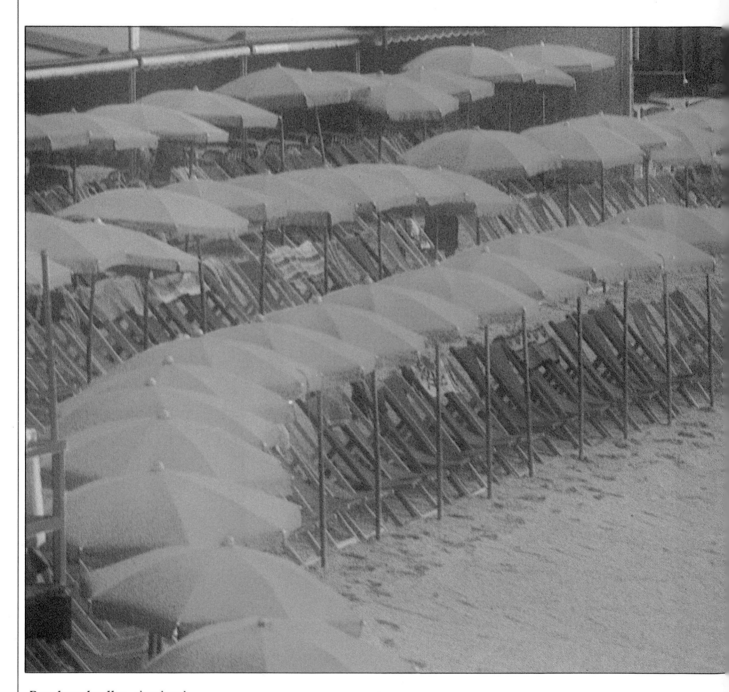

Beach umbrellas, *abandoned during a rain shower, sweep in a delicate green arc across the whole picture. The blending and softening of hues on a misty day such as this often creates marvelous opportunities for color photographs.*

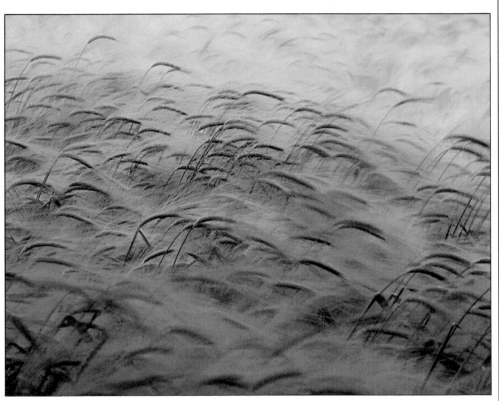

Windblown barley has been blurred here by the choice of a shutter speed too slow to stop the tips of the stalks waving. By this means the photographer has subtly muted the overall color to pale green.

A motorcycle racer banks over to take a corner, the bright red of the rider's suit standing out against the dark of the track. The photographer used a special prism filter to create the repeated image that gives such a dramatic impression of high speed.

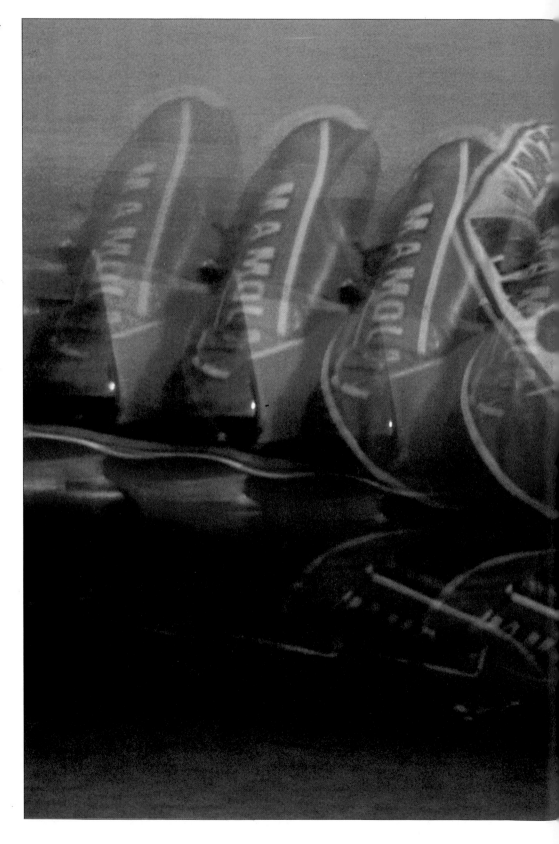

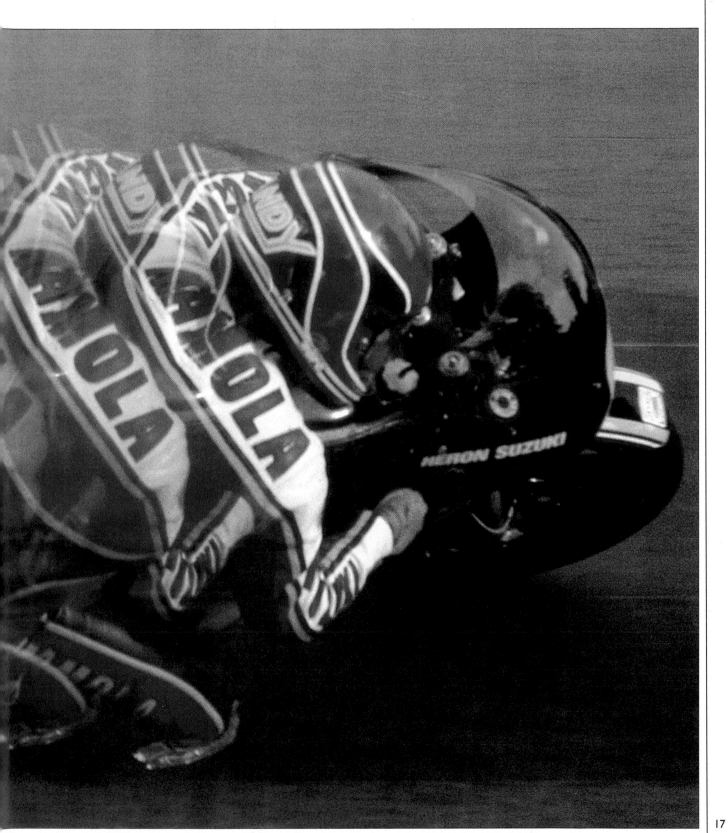

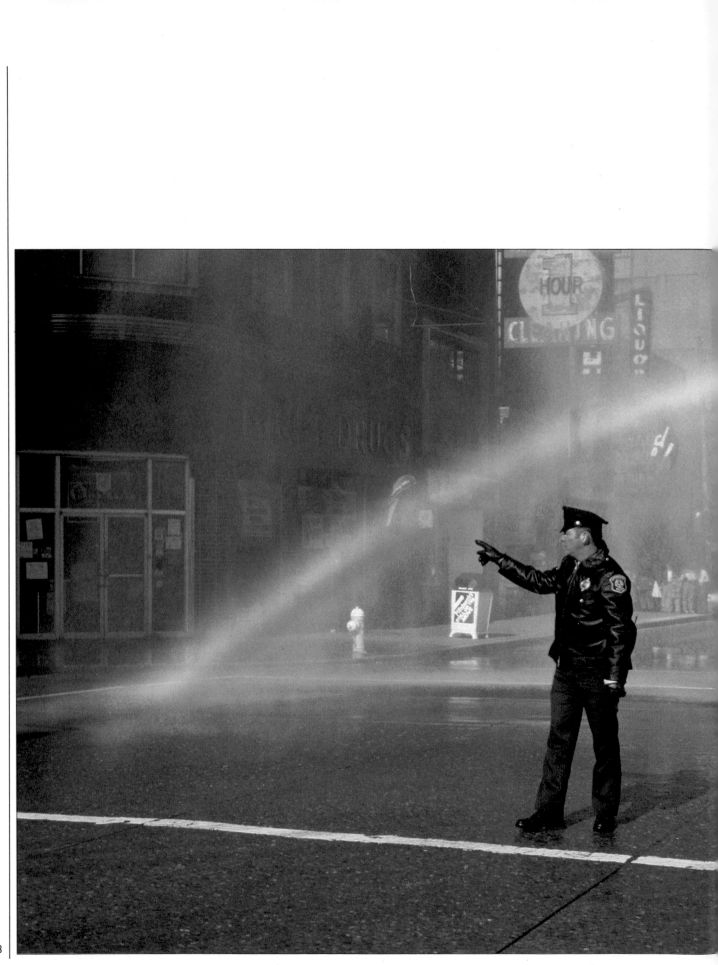

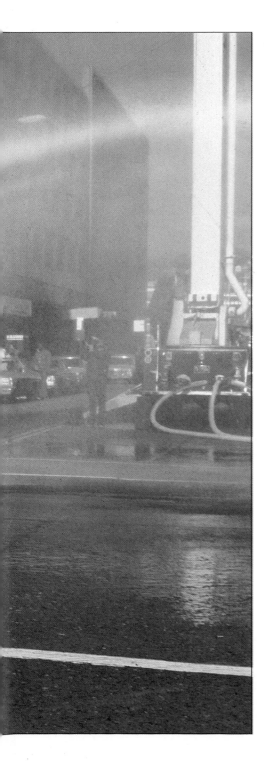

COLOR AND COLOR FILMS

One of the most fascinating things about color photography is the enormous range of color effects that can appear in your pictures. Very often, colors do not turn out the way you expected – they may be stronger or duller than you remembered them, or there may be an overall tinge of a single color, of which you were not aware when you took the picture. However, this unpredictable quality is not really so surprising: color photography involves a delicate relationship between the colors of objects, the colors of light, and those of color films.

The section that follows begins by looking at the source of all colors – light itself. Because direct sunlight at midday combines all the colors of the spectrum, the illumination it provides may appear colorless. But other light sources, such as light bulbs – and sunlight itself at evening or in the morning – have a definite bias toward orange or red. A person's face can look quite a different color depending on the quality of the prevailing light. Films are highly sensitive to these color differences. Moreover, various types and brands of films differ in the emphasis they give to some colors at the expense of others.

To achieve the best results in color photography, you need to make sure you are using the film most suited to the type of lighting. A few slide films are designed specially for use in the orange light of tungsten studio lamps. Alternatively, you may be able to modify the light passing through the lens by using a filter. The ability to control precisely the colors that appear in your pictures is the first step toward using color creatively.

A rainbow in the fine spray falling from an overhead fire hose reveals the colors making up the sunlight flooding a Pittsburgh street scene. Although the colors of light are seldom seen so clearly, everything in the world owes its color to the light that illuminates it.

19

Light and color vision

To understand why we see the world in a variety of colors, you need first of all to look at the nature of light itself. Like X-rays or radio waves, light is one of the forms of electromagnetic energy that radiates in waves from energy sources such as the sun — somewhat as rings spread out from a pebble thrown into a pond. The essential difference between the light falling on this page and the signals picked up by a radio or television set is one of wavelength — the distance from the crest of one wave to the crest of the next. In some forms of energy the wavelength is infinitesimal — no more than a billionth of a milli-meter; in others it can be as much as ten kilometers. The wavelengths of visible light are around 1/2000th of a millimeter.

For the photographer, the important difference between light and any other form of radiant energy is the fact that we can see it. Out of all the wavelengths of energy radiating through the atmosphere, the nerve endings in our eyes are sensitive to only a narrow band that constitutes the visible spectrum, diagrammed below. The ultraviolet and infrared wavelengths on either side of this band are invisible to our eyes. The eye and the brain assign different

How we perceive the colors of light
The large diagram below graphically simplifies a complex process by which we see colors in the light radiating from the sun. Light itself forms only a tiny band of wavelengths among other forms of energy spreading out in intermingled waves of widely differing lengths. Yet the relatively narrow band of visible wavelengths provides our whole multicolored world of light. When a prism splits light into its individual wavelengths we can see a spectrum of colors, as in the photograph at right. And, remarkably, we see this by interpreting signals from just three types of cells in the retina, sensitive to wavelengths of red, green or blue light, enabling us to perceive a myriad of different hues.

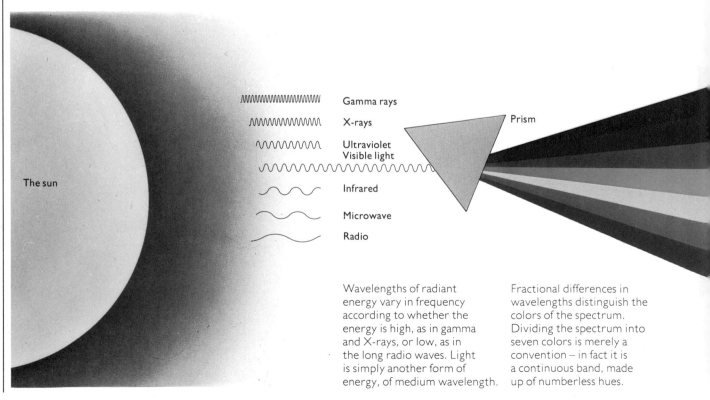

The sun

Gamma rays

X-rays

Ultraviolet
Visible light

Infrared

Microwave

Radio

Prism

Wavelengths of radiant energy vary in frequency according to whether the energy is high, as in gamma and X-rays, or low, as in the long radio waves. Light is simply another form of energy, of medium wavelength.

Fractional differences in wavelengths distinguish the colors of the spectrum. Dividing the spectrum into seven colors is merely a convention — in fact it is a continuous band, made up of numberless hues.

hues to those wavelengths to which they are sensitive, interpreting the longest of them as red and the shortest as violet. In daylight, the wavelengths that make up the visible spectrum are complete, mixing together in such a way that the light appears white, or colorless. But a rainbow reveals the fact that the light actually contains all the spectrum colors, because the droplets of water break apart the individual hues. You can separate the colors of the spectrum simply by passing a beam of white light through a prism, as shown below. And by using a filter to take out one or more of the colors, you can make the light itself look colored rather than white. For example, a blue filter absorbs red and green lightwaves, allowing only blue to pass.

The reason that we see the world in a multitude of colors is mainly because different substances and surfaces absorb certain wavelengths of light and reflect others back to the eye. The eye then reads the reflected light in terms of the predominant wavelengths, and assigns a hue to it. Thus a tree looks green and a poppy red because they absorb and reflect different wavelengths of the light that shines on them both.

Soap bubbles, like the prism, bring out the colors in white light (right). The surface of a bubble varies in thickness and passes or reflects different colors of light accordingly. The result is a shimmering pattern of shifting colors.

Why objects look colored

When rays of light fall on a surface, wavelengths of some colors are absorbed, others reflected. Those reflected back to the eye determine how we perceive an object's color (below).

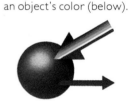

Here the ball looks red because only wavelengths we perceive as red are reflected: all the other wavelengths are absorbed.

When wavelengths of more than one primary color are reflected back (such as red and green), they create a new color (here, brown).

Shorter waves

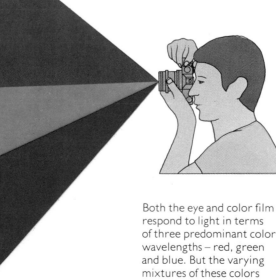

Both the eye and color film respond to light in terms of three predominant color wavelengths – red, green and blue. But the varying mixtures of these colors mean that we can perceive countless gradations of hue.

If an object reflects all the spectrum's wavelengths and absorbs none, it will appear to be colored white, as does this ball.

Longer waves

The balance of color/1

The sun, a candle and a glowing coal all give off light as they release heat. But the color of the light that each produces is not identical, because the heat at which each source burns varies enormously. As a result, each source sends out a different mixture of wavelengths, with substantial effects on the colors of the objects illuminated. These effects are particularly noticeable in color photographs because films are balanced to give accurate colors in light of a particular wavelength mixture.

There is no point in relying on your eyes to detect minor changes in lighting. We see what we expect to see, ignoring subtle variations of color. A white shirt will still look white to us whether we see it in sunlight or indoors under artificial light. However, film records the predominant color of the lighting literally. Ordinary film for daylight use is balanced for average noon light in which the illumination comes mainly from the predominantly white light of the direct sun. Unless you correct it with a filter, lighting of a very different balance will inevitably change the colors in photographs taken with this same film, producing unreal colors – an effect known as a color cast.

The color of a light source does not depend only on its heat. For example, atmospheric factors come into play when we consider the way daylight changes in color. As a result, whereas daylight or noon sun appears neutral, the wavelength mixture reaching us varies as the sun rises or sets. Similarly, clouds or haze filter out some wavelengths by absorption, or scatter others so that they predominate in the light reflected from the sky itself. On a clear day, the sky looks intensely blue because of the scattering of blue wavelengths by atmospheric molecules. And this means that the light is much bluer in shaded areas, where illumination comes only from the sky, than in areas reached by the light of direct sun.

Light sources can be codified according to their so-called color temperature on the kelvin (k) scale. Temperature is the mode of measurement because a heated object, such as an iron bar, will change color from red through yellow and white to dazzling blue as the temperature increases. But remember that the kelvin number assigned to a light source relates to the color of the light produced, not to the physical heat of the source. Thus, the color temperature of daylight may be higher (because bluer) on a cold overcast day when all the light is coming from the sky, than in direct warm sun. At midday, average (photographic) daylight has a color temperature of about 5,500k, and it is for light of this color temperature that most color films are balanced, giving accurate color in normal outdoor scenes.

The color temperature scale
Whether you are photographing in artificial or natural light, all light sources have a certain preponderance of wavelengths that give the lighting a particular color. These different colors are shown below as a band of rising color temperatures, extending from the reddish lighting characteristic of candlelight and sunsets up to the bluer light normally found in pictures taken in the shade or on overcast days. The color effects of natural light in various conditions are illustrated above the color temperature band, those of artificial light sources below the band.

Candles
Oil lamps

Household
lightbulbs

Sunrise or
sunset

2,000k

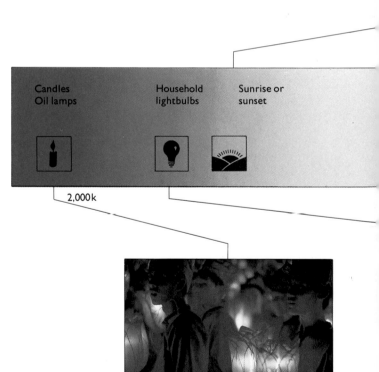

Candlelight, in the absence of any other light source, produces a strong reddish-yellow cast, because a candle burns at a far lower temperature than the noonday sun. Although the light is usually too dim to show much detail, pictures taken by this source can have strong atmosphere, as in this shot of a Bangkok procession.

At sunrise and sunset, natural light is at its reddest because the light has to travel farther through the atmosphere. As a result, many short blue wavelengths are absorbed, allowing the longer red wavelengths to predominate. Below, the sunset sky has tinged the gray rocks of the Grand Canyon with red light.

At noon, with a few white clouds, daylight is neutral in color. Because this is the light for which most films are balanced, the colors of objects under noon sunlight look correct. The picture of kites on a beach was taken in these conditions – and shows pure whites and reds in the nearest kite.

In the shade, photographs often have a strong blue cast, because objects are illuminated only by light reflected from the blue sky, and receive no direct sunlight. Overcast skies also usually produce bluish colors. Here, a cool blue light suffuses both the white ibis and the water.

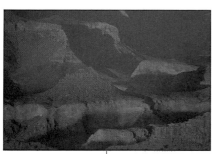 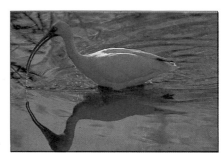

Morning or evening sunlight

Average noon daylight
Electronic flash

Hazy sky

Heavily overcast sky

Reflection from clear blue sky (shade)

5,500k

16,000k

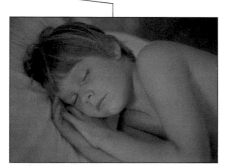 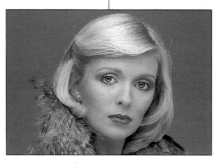 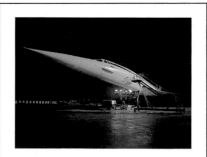

Household bulbs burn hotter than candles, but produce a much yellower light than does the sun. This means that with ordinary daylight film in the camera, pictures taken in room lighting usually have an overall orange cast. The picture of a sleeping child shows that the warm effect of this light can suit skin tones.

Electronic flash is balanced to match the color temperature of noon daylight. Thus, you can use it safely indoors or out, without creating color casts. Had this studio flash portrait been taken by the light of tungsten photographic lamps, a special slide film (described overleaf) would have been needed.

Fluorescent light
This does not belong on the color temperature scale because it is not a burning light source. The color casts it produces vary greatly. Above, the greenish lights of an airport runway give the Concorde a surreal look.

The balance of color/2

Not many situations in photography call for any special measures to cope with the color quality of the light. Most pictures are taken outdoors by the light of the sky or sun, and slight variations in color caused by weather conditions or time of day often add pictorial interest rather than cause problems (see pages 56-74). But sometimes a light source produces a color mixture too far removed from the lighting for which your film is intended. When this happens, unacceptable color casts may appear in the picture – for example, green flesh tones in a portrait. You can avoid this situation either by choosing special film or by using filters to modify the light as it enters the lens. Color print films have a fair tolerance to different kinds of light because corrections can be made in processing, but with slide film the balance is crucial.

A special slide film is available for shooting indoors under tungsten bulbs. However, this film is balanced for powerful lamps used in photography studios, and will not entirely remove the unnatural color cast produced by ordinary, lower-watt bulbs. Alternatively, conversion and light-balancing filters are available in a complete range of colors, including those for fluorescent lighting. Some of the most useful filters are demonstrated on these two pages.

Daylight and film balance
Most color films, print and slide, are designed to work best in daylight, accurately reproducing the colors we see (right). Almost all the film you use will be balanced for daylight. The exception is slide film balanced for tungsten lighting. This film has a bluer quality overall, rendering a scene lit by orange light from tungsten lamps as near white. Used in ordinary daylight, the film produces unnatural blues (far right).

1 – Daylight with daylight film

2 – with tungsten film

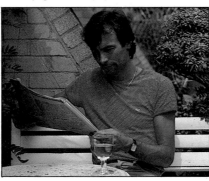
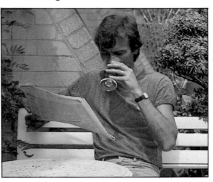

Tungsten light and film balance
In tungsten light, whether from ordinary bulbs or special tungsten photographic lamps, film balanced for daylight records an orange or yellow cast (right). Although the warm color can be attractive, this is not how we see the scene. For more accurate results, the light can be partly corrected with a bluish No. 80A filter (far right, above). However, for greater accuracy, use slide film balanced for tungsten light (far right, below).

1 – Tungsten light with daylight film

2 – with No. 80A filter

3 – with tungsten film

Filtering fluorescent light

Although fluorescent lamps look white to the eye, they produce an unpredictable variety of color casts on film – ranging through yellow, blue or green. The scene in an airport control tower at right has a distinctly greenish cast from the fluorescent tubes. A fluorescent filter (far right) does not balance the light perfectly to the daylight film, but does give a warmer, more natural look.

1 – Fluorescent light with daylight film

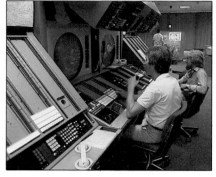

2 – with fluorescent filter

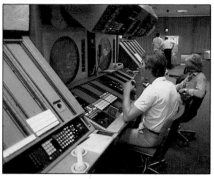

Filtering overcast daylight

Heavy clouds scatter the shorter blue wavelengths of sunlight, raising the color temperature of the light and producing a blue cast on film (right). This still-life was rephotographed with a No. 81B pink filter to reduce the proportion of blue (far right). Many photographers use this filter as a matter of course on cloudy days.

1 – Overcast daylight with daylight film

2 – with No. 81B filter

Corrective printing: tungsten light

Filtration control in printing may restore accurate colors to print film. The portrait photographed in household tungsten light (right) has a strong orange cast. By asking the printer for a reprint with corrective filtration, (far right), the photographer secured a much more accurate result.

1 – Tungsten light, uncorrected

2 – with corrective printing

Corrective printing: fluorescent light

The green cast from fluorescent light is more obtrusive than the orange from tungsten lamps. This portrait, shot by the light from fluorescent tubes in an office (right), has an unpleasant color if uncorrected. When asked to compensate, the printer produced an improvement (far right), but has not succeeded in imitating the natural colors of a daylit scene.

1 – Fluorescent light, uncorrected

2 – with corrective printing

Choosing color film

Most photographers simply want the film they use to record accurately the colors they see. Thus it may seem surprising that such a range of color film is available. For 35mm cameras, there are several dozen types of daylight and indoor films. The reason for this diversity is that each film has its own characteristics, and you may want to choose different films for different purposes.

The initial choice, of course, lies between films for slides (transparencies) or for negatives from which you can make prints. Beyond this, a film's sensitivity to light is the main consideration. Fast films are very sensitive, and give the photographer great versatility, but slower, less sensitive films have other advantages. For example, they provide a good range of tones between light and dark. And because they make use of finer grains of light-sensitive silver salts to form an image, they can look sharper and are less grainy in big enlargements than photographs taken on faster film.

Although grain size is a consideration when choosing color film, the film's color rendition is often more important. A photograph of the same scene taken on different types of film will vary slightly but distinctly in color, as the pictures below show. One film may record reds with special intensity. Another may distinguish more clearly colors that are closely similar. Yet another film may give the picture a warmer or cooler appearance overall – this is particularly noticeable in neutral color areas such as black, white and gray, and in skin tones. In photographs, it is often in the skin tones that we are most sensitive to variations in color values and most disturbed by unnaturalness.

Variations of color are usually quite subtle, and are most obvious when you make comparisons between slide films; the printing process tends to reduce the differences between negative films. In general, photographers form their own preferences for color film. The best way to make a choice is to try out a number of films, and decide which you like most. You may even want to use two different films, choosing for portraits a type that produces very natural skin tones, but preferring a different film for landscapes, where you may feel that the rendition of blues and greens is more important. The difference in the qualities of the blues is one of the features of the color films shown below.

The color characteristics of film
This garden still-life incorporates a wide range of colors. Shot on different types of film, the colors show slight but distinct differences – for example, in some the blue is stronger, in others the red. The green is particularly strong in the image second from right. However there is no "best," because color judgments are largely subjective.

Subtle colors and flowing movement emphasize the grace and beauty of dance. Here, the photographer chose high-speed film to cope with the dim light of the rehearsal room. This film has helped to soften the colors.

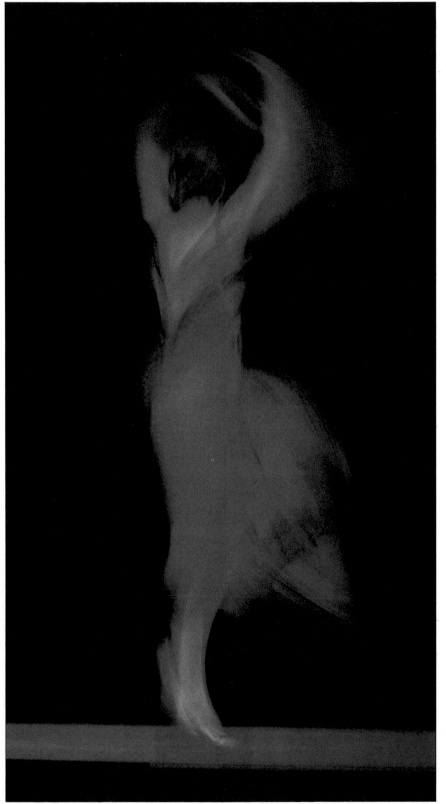

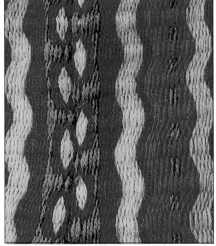

A vivid piece of woven fabric relies for its impact on the juxtaposition of primary colors. The photographer took the picture with slow transparency film, which has moderate contrast and good color fidelity, suited to the reproduction of vibrant hues.

How color film works

Color print film is like a layer cake (above) made of gelatin containing grains of silver salts. Each layer records a different part of the visible spectrum – red, green or blue light. Processing creates a silver image where light was absorbed in each layer. At the same time, a dye image appears – in color exactly opposite to the color for which the layer is sensitized. For example, the blue-sensitive layer forms a yellow dye image. After bleach and fix have removed the silver image, the dye layers (visible in the magnified cross-section above) form the negative from which a positive print is made. Processing of color slides is more complex because the film must form a positive picture. During processing, a second development introduces transparent dyes that form the image, subtracting appropriate colors from the light that passes through the slide.

Slide film

To achieve precision and brilliance of color, many photographers prefer to use color slide film – often called transparency or color reversal film. Because this produces a positive film image directly, without an intermediate printing process, any adjustment the photographer makes to the camera's controls leads directly to a corresponding change in the appearance of the final picture.

Although color slides need projection or enlargement to be seen properly, they display great brilliance and color saturation. We see slides by transmitted, rather than reflected, light. Therefore, the range of brightness is higher – a slide usually has more snap than a print (see overleaf).

This impact derives partly from the higher contrast of slide films – they allow little latitude for over- or underexposure. On a dull day, or under flat lighting, this is an advantage, but on a bright sunny day, when the shadows are very dark, and the highlights bright, high contrast can prove a problem. At worst you can lose highlight or shadow detail altogether, depending on how you set the exposure.

As a general rule, blank highlights – for example pale, washed-out features in a portrait – are more likely to spoil a picture than are murky shadows. For this reason, if you are uncertain about the light, some underexposure of color slide film is better than overexposure.

Regular users of color transparency film often deliberately underexpose all their pictures to take account of this – usually by a third or half a stop. Even in low or flat lighting conditions, slight underexposure leads to richer, more saturated colors. You can also underexpose by setting your camera's film speed control to a slightly higher speed – say ISO 80 if you are using ISO 64 film.

When the contrast between highlights and shadows is very high – in strong sunlight or when shooting into the sun – bracketing exposures increases the chance of getting just the picture you want. For the sunset pictures shown below, the photographer used this simple technique, making exposures at intervals of one stop above and below the setting indicated by the camera's meter.

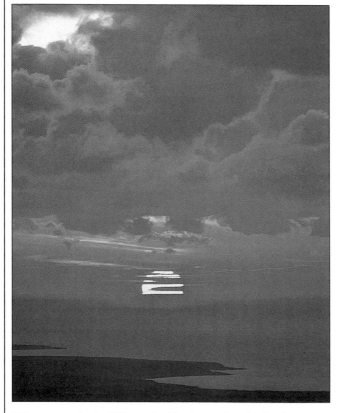

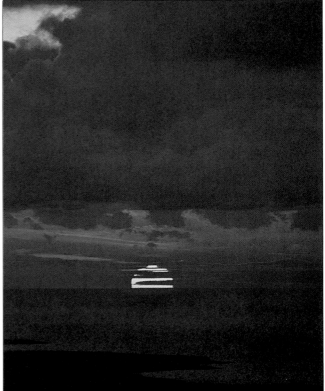

The sunset looks different in this picture than in the three on the right, because the photographer varied or bracketed the exposure so that he could choose the best. The image above received two stops more exposure than the meter indicated. The result is pale but pleasing, with a satisfying balance of tones.

One stop overexposure gives the best balanced result. There is more detail in the sand spit and clouds compared with the pictures on the right.

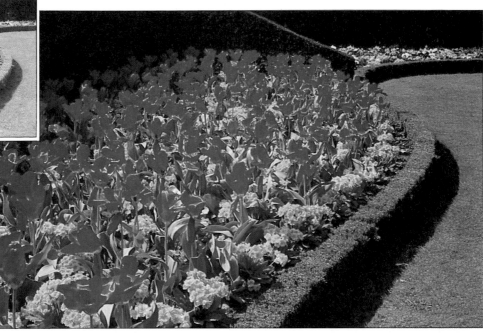

Underexposure of color slide film can add to color saturation and avoid the burned-out appearance of sunlit highlights. For the picture of a flower bed (right), the photographer deliberately set the camera to give half a stop less exposure than the meter indicated. The inset shows the "correct" exposure setting (above).

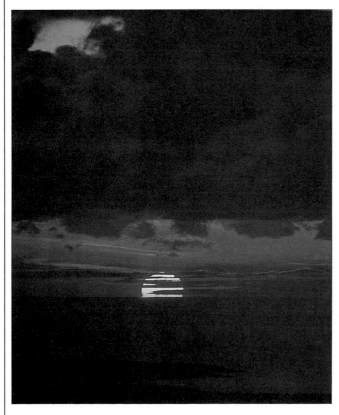

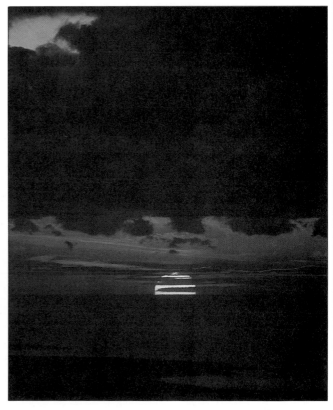

At the metered setting, most of the cloud and sea areas are left as broad masses, but in compensation the red sky is particularly rich.

One stop underexposure produces an image that loses almost all the detail, but is still acceptable because of its dramatic effect.

Print film

While slide films have the advantage of brilliance and color intensity, you need to project them onto a screen or use a small viewer to see them at their best. Many people prefer to see their pictures in the form of a print which they can hold in their hands. And because of the brilliance of the original, a paper print made from a transparency rarely seems as satisfactory. If your principal aim is prints, then color negative film may be your best choice.

Because a print is viewed in different conditions to a slide, its colors may appear more muted, and some photographers prefer to work with color negative film because they consider that the hues and tones of a print have more subtlety than those of a slide. Another significant difference is the low contrast of a negative compared with a slide. If you hold a negative up to the light it will look relatively dull. However, because the negative is only an intermediate step on the way to a print, low contrast is not the disadvantage it may seem. It means that negative film can be corrected for some over- or underexposure. As a result the film is ideal for

simple cameras that do not have sophisticated ways of avoiding exposure errors. Even when loaded into an SLR camera, negative film needs less care in assessing exposure than does slide film because to a certain extent exposure errors can be corrected during printing.

Printing a color negative can be much more than just the mechanical process of reversing colors to their normal hues. First, a color-correcting mask that gives the negative an orange tint has to be removed. Then, and more significantly, printing provides the opportunity to control selectively the overall or local color of the picture, and to correct for errors in color balance as well as exposure.

For the many photographers who print their own negatives in home darkrooms, the printing process can, in fact, be just as creative as actually taking photographs. Even if you do not have a home darkroom, you can exert some measure of control over the appearance of the final print by examining a contact sheet (see opposite) and giving appropriate directions to the color laboratory.

The unreal hues of a color negative (right) are little help in judging the final color of the print (above). Part of the problem is the orange dye mask that covers the whole of the negative. This helps to produce more accurate colors in the print, but makes interpretation of the reversed colors more difficult. The best general guide to how a negative will print is its density. A thin negative – one that is underexposed – has little visible detail and will produce a dark, muddy print. By comparison, a dense negative – one that is overexposed – creates fewer problems for the printer.

Purple in the negative will appear as yellow in the print – the orange mask has combined with blue (the complementary of yellow) to give the purple appearance.

Yellow in the negative also forms its complementary color – blue – on the print. The orange mask distorts yellow only slightly.

Green in the negative will print as red – the gloves in the girl's pocket.

A contact sheet, on which an entire roll of film has been printed, provides you with a convenient working guide to the appearance of all the pictures on the roll. Most laboratories can make a contact sheet, from which you can then choose which images to enlarge, say how they should be cropped to improve the composition, and decide if color correction is needed. From this roll, the photographer picked out the image of the boat, and asked the printer to bring out an overall warm color and crop the picture on the left-hand side. Both these changes would be simple to make in a home darkroom.

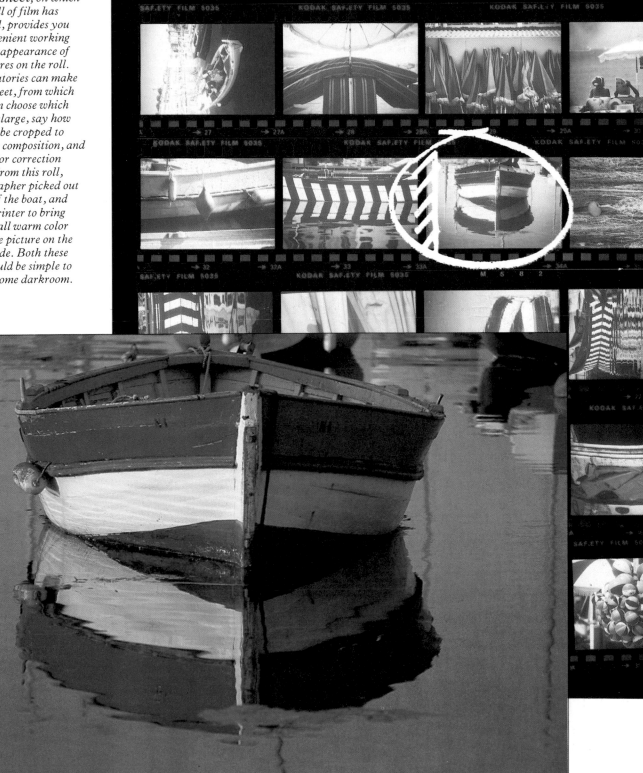

Instant-picture film

The obvious and spectacular advantage of an instant-picture camera is that it provides a finished print almost immediately. But apart from this fundamental attribute, an instant picture has a certain unique and identifiable quality – because the film reproduces colors by a method different from that used for any other type of film.

The elaborate chemistry of instant-picture film effectively packs a mini-darkroom into the sheet of film itself. Once development is complete, the image you see is the same size as the image recorded on the film, so that no quality is lost by enlargement. However, because the plastic-wrapped sandwich of film has to act as the print as well, the final image lacks some of the fineness of detail that can be achieved with conventional film. At the same time, the sealing of the actual print surface produces a slight diffusion of the colors. The combination of these two qualities gives the instant image its unique look. You will find that some subjects are actually flattered by the characteristic tonal and color qualities of instant-picture prints.

In general, instant-picture film will give best results when the light is not too bright and contrasty, so that you can avoid the danger of colors being lost in inky shadows or pale highlights. The richness of the colors on the page opposite shows what can be achieved in more even lighting. Many of the newer instant-picture cameras reduce the problem of high contrast by providing automatic flash to lighten dense shadow areas caused by particularly bright sunlight.

One of the great attractions of instant-picture photography is that you can take advantage of the immediacy of the process by assessing results on the spot and using them as the basis for improvements. For example, the picture below was the best of several attempts to produce an image in which the moving ball stayed within the frame. In this sense, an instant-picture camera can be an invaluable tool for learning how to compose better pictures. No other kind of photography enables you to see so quickly and clearly how a three-dimensional scene will translate into a flat image.

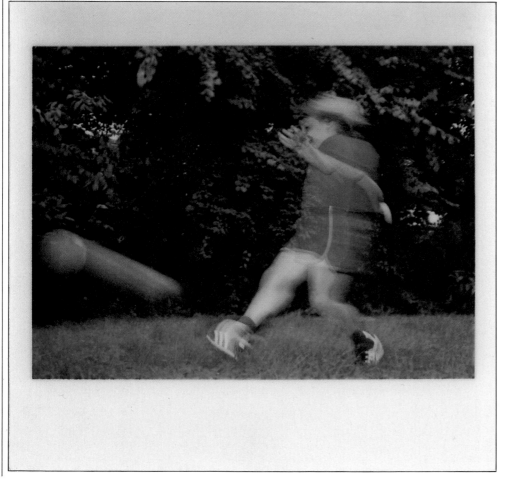

The boy kicking a ball was the best of several shots. Because the photographer could see the results within a few seconds, he was able to take more pictures until he got the precise effect he desired, with the soccer ball included in the frame. The image appears sharp at the end of a trail of movement because the automatic flash of the camera fired to give extra light while the shutter was open. This froze part of the movement.

Instant pictures make an ideal visual notebook (right). On holiday, you can use them to make personal "wish you were here" messages to send to friends.

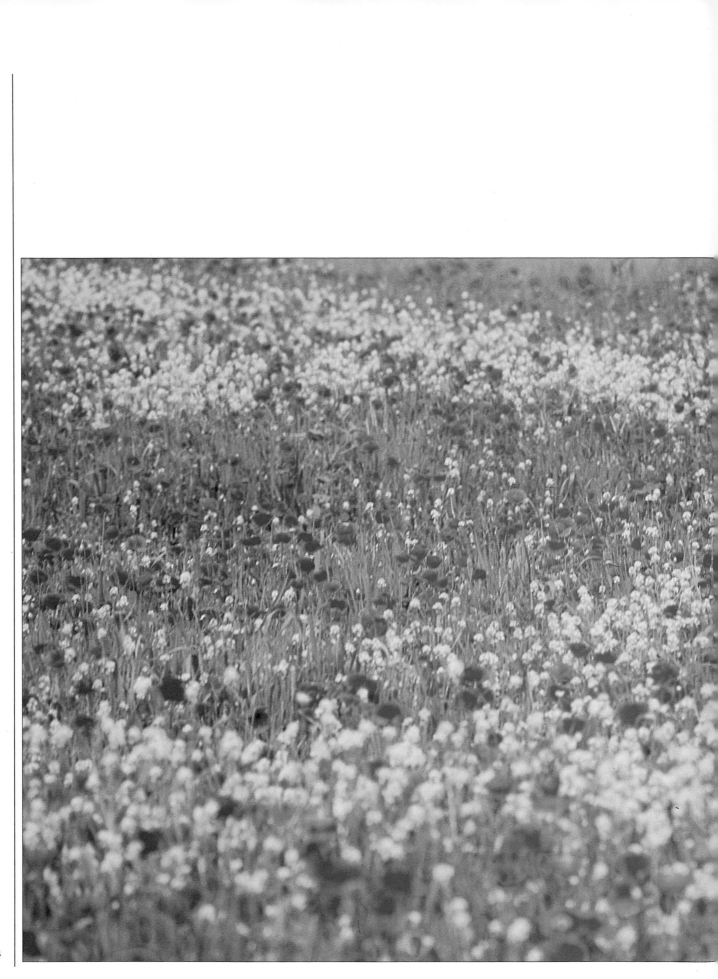

COMPOSING WITH COLOR

Color does more than bring photographs closer to reality. Particular colors often provoke strong responses in the viewer, creating tension or excitement, establishing a soothing feeling of equilibrium or jarring the senses. These powerful reactions may be independent of the subject of the picture, for we react to color emotionally.

Controlling the strength or placement of colors can enable you to produce more effective color pictures. On a few occasions you will have the opportunity to alter the colors of the subject – you could, for example, ask someone to wear a particular color for a portrait, or change the color of a backcloth. Much more easily, you can manipulate the colors that actually appear in the image by using techniques of composition outlined in the section that follows. For example, you can choose a viewpoint or a lens to include certain areas of color and exclude others. You can fill the viewfinder frame with vivid hues, as in the picture here, or restrict bright color to just a small area. And you can juxtapose two or more colors for either a calming or a vigorous effect. Colors create mood, and by using them in a controlled way you can give pictures just the impact or subtlety you want.

A sea of color, created by the heads of innumerable wild flowers, sets up a lively and joyous mood. In this picture, close framing has concentrated attention on the interplay of the two colors, rather than the topographical details of the landscape.

Color psychology

Individual responses to color are highly subjective. But although most of us feel – rather than think – about colors, effective photographs often come from understanding the basic factors that influence people's reactions to color.

Some reactions have a physiological basis. For example, yellow strikes us as lively partly because the cells of the retina are especially sensitive to yellow-green wavelengths of light. Some color combinations appear vibrant because in looking at them our eyes have to make rapid adjustments between different wavelengths, whereas combinations of colors closer in wavelengths appear harmonious and restful. Again, bright, vivid colors – such as the red of the leaves in the picture at right – tend to seem nearer than do more muted hues.

More often, however, psychological factors are at work. These may arise from personal experiences, leading us to develop preferences for certain colors in clothes or furnishings. However, in learning how to use color in photography, such personal reactions are less relevant than other responses to color that are very widely shared – for example, the sense of warmth or coolness. Reds and oranges commonly seem to have an actual physical warmth, perhaps by association with fire and sun, whereas blue, by association with water, shade and dawn, seems cool. Another widespread feeling is that some colors are softer than others – pastel hues, such as pinks and pale greens, appear more delicate and gentle than pure, intense colors, such as yellows and reds, which can seem dramatic, strident, or even aggressive. By understanding such general reactions to color, and by using one combination rather than another, you can consciously create a whole range of emotional effects.

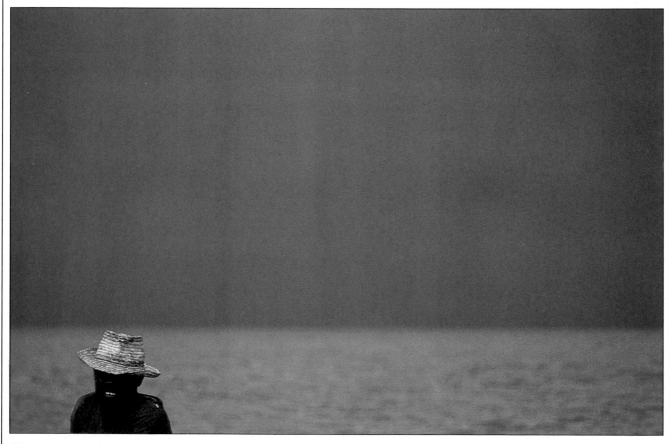

Unbroken bands of cool blue convey a sense of peace and tranquillity. The atmosphere evoked by colors depends not only on their hue and brightness, but also on how they are arranged – horizontal lines are much calmer in feeling than vertical or diagonal lines.

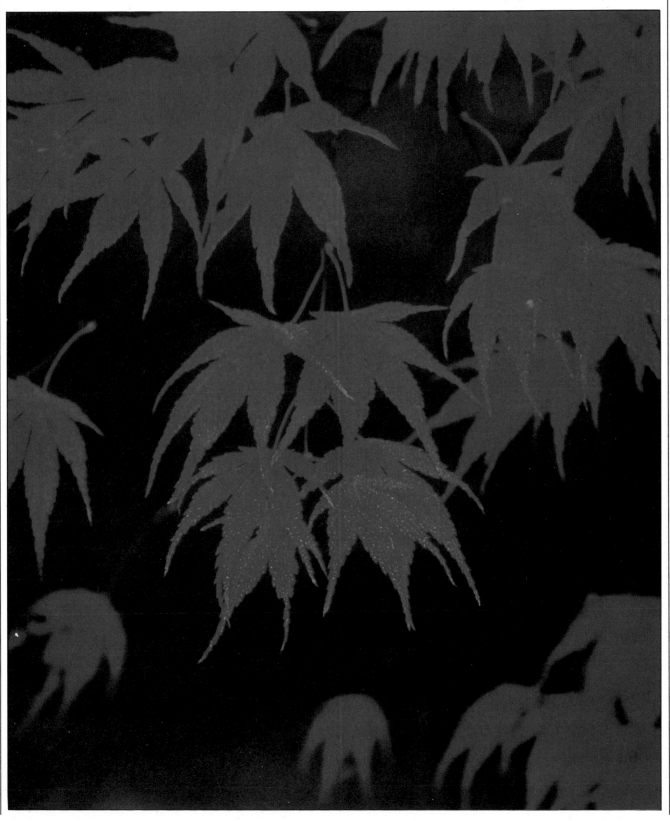

Bright red leaves *seem almost to leap from the page in this vivid image. Whereas bright, warm colors advance toward us, cooler, darker colors appear to recede. Here the muted background emphasizes the vibrancy of the leaves.*

The richness of color

Strong colors have a more direct impact than those that are muted. Of course, many good photographs have soft colors, for these subtler hues often contribute to the sense of balance or atmosphere in a shot. But when you want colors to contribute drama or have a vigorous effect, you usually want them to appear at their most vivid.

The strongest colors are said to be fully "saturated" – a term borrowed from the dyeing industry. In photography, saturated colors are those that consist of one or two of the primary colors of light – red, green or blue – but not all three, because that introduces an element of grayness. At the same time the saturated colors look most vivid in a certain kind of lighting. For example, a pure red flower will appear more vivid than one that has a brownish tinge, but both will appear most colorful in light of medium intensity. Bright sunlight can make a color

appear less vivid by lightening it – as the left-hand picture of the leaves below demonstrates. Shade, on the other hand, can make the colors appear darker.

When you have identified an area of color that you want to emphasize, the following techniques may help you take full advantage of its richness. First, consider whether you can move around until the angle at which light strikes the subject brings out the strongest color. Unless the subject reflects glare, a position with the sun behind the camera will usually be best. Second, to reproduce the color at maximum saturation, take the exposure reading from the chosen part of the scene rather than the whole view. Although this may underexpose duller parts of the subject, the contrast can enhance the chosen color area. Finally, with slide film, deliberately underexposing by a half-stop tends to enrich color, as well as producing good shadow detail.

1 – Glare reflecting from a shiny bush (above) gives the entire photograph a washed-out appearance. The other two pictures were taken in the same light, showing that color saturation in direct sunlight depends on the lighting angle.

2 – Backlighting, with the bush between camera and sun, gives dramatic contrast in which the leaves are very bright. But because the light shining through the leaves is too strong, the colors appear somewhat washed-out.

3 – Bright light without glare shows fully saturated leaves. The photographer took up a position different from the first two, altering the angle between sun, subject and camera. Slight underexposure increases the richly colored effect.

Color saturation
Pure colors lose intensity if they are either darkened or lightened. The saturated hues at the center of the diagram are progressively desaturated by the addition of white or black. In photography, this means that colors lose strength in shade, or as light glares from a surface. Exposure errors also make colors look less vivid.

Low light mutes even the pure colors of these flowering trees, an effect that is increased by the haze. The green foliage is so dulled that it is almost gray in color. In conditions such as these, only the strongest colors, perfectly exposed, will preserve any intensity.

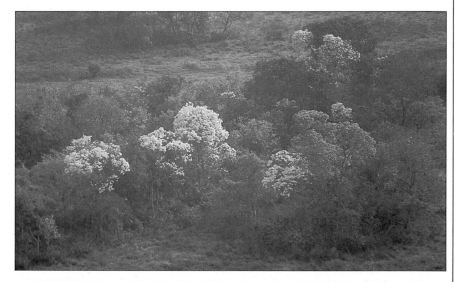

Perfectly lit by soft window light, a bowl of fruit shows the richness of fully saturated colors. But even here, the effect of light reflecting from the subject can be seen in the highlights on the green apples. With slightly more exposure, these areas would have begun to appear too light and washed-out.

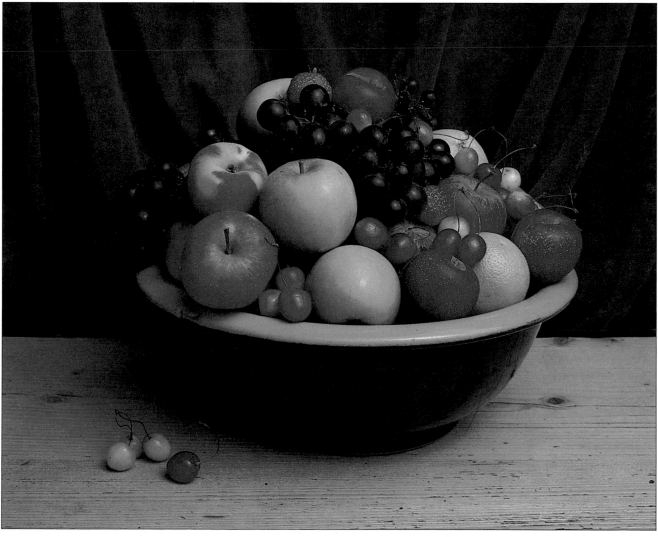

The color accent

Colorful scenes make naturally colorful pictures, but much of our environment – particularly the concrete wasteland of modern cities – is drab. The weather, too, can have a profound effect on color: snow blankets everything in purest white, and a scene that glows with color in sunlight can look gray and forbidding in drizzle. Occasionally, a picture made up simply of subtle shades of gray has a quiet, pearly beauty of its own (see pages 44-45), but more often, a colorless scene looks simply dull.

Yet by introducing a single patch of color into just such a picture, you can make the image pulse with energy, as in the picture of a dockside at top right. Even a small accent is enough to make a difference. For example, the graveyard on the opposite page looks drab and depressing if you cover the flowers in the picture with your finger. But with the splash of yellow in the foreground, the picture springs to life as a harmonious image. The warmth of the yellow draws attention to other, more subtle patches of muted color – the moss on the tombstones, for example.

The colors that best provide sharp accents are the warm ones – reds, yellows, and fiery oranges. These colors jump out from the picture surface and command the viewer's attention. Cooler colors, such as blues and greens, often are less effective. Unless they are very bright and luminous, you may need to use them more liberally if you want to enliven a predominantly gray picture.

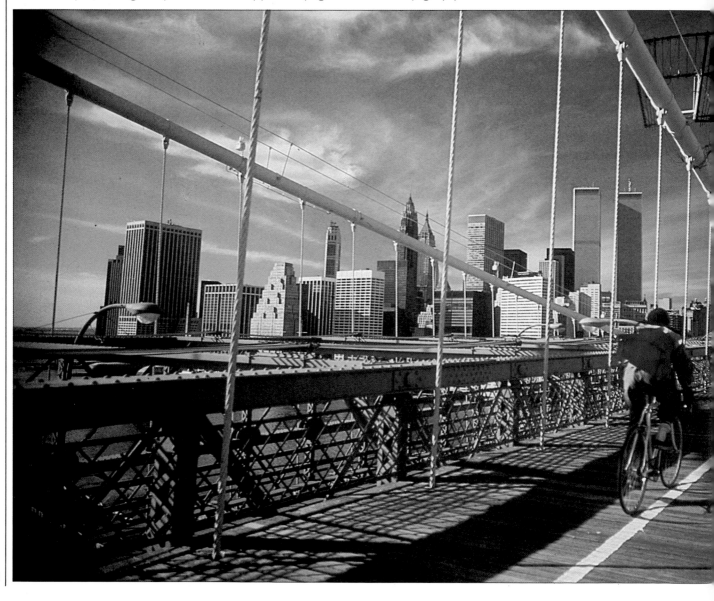

A fishing dock stands empty and silent as storm clouds sweep in from the sea. The heavily overcast sky had drained the sea of color – but intensified the bright pink of a buoy – so the photographer stepped back to include this foreground accent.

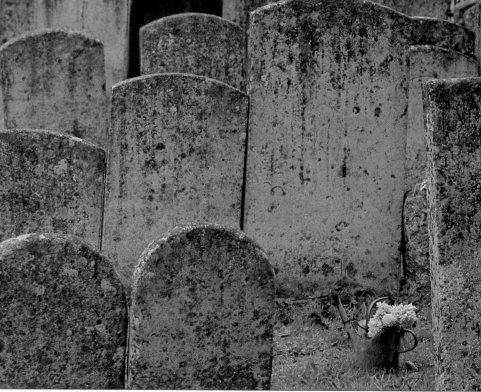

Brooklyn Bridge is such a popular subject for New York photographers that presenting an original view is difficult. Yet in the picture at left, the cyclist's red pack provides a brilliant patch of color that focuses the eye on his route toward the grays, blues and whites of the Manhattan skyline.

Yellow flowers in an improvized vase break up a drab pattern of tombstones. Because the stone slabs look so gray and ponderous, the blooms seem to glow with light and color – whereas on a florist's stand, their brilliance might be lost among the other competing hues.

The dominant color

The ability of modern color film to reproduce all the brilliant colors around us tempts photographers to fill the viewing frame with the richest mixture possible. Sheer profusion of color sometimes works well, but if you are not careful, the picture becomes a jumble of clashing hues.

Often, you can exploit rich, bright color more simply by allowing just one powerful hue to dominate the image. Restricting the color palette in this way can concentrate the impact of the picture – in the startlingly blue seascape shown below, the single block of color seems more emphatic than would several colors jostling for attention.

This way of using color often works best when the dominant color forms a unified background – as does the bright yellow of the umbrella on the right. The more intense the color, the more it will dominate the image, but paler color areas can be used to frame areas of the photograph that are a different hue. For example, in the picture on the right, the lemon of the umbrella makes a lively and vivid backdrop for the girl's shy smile.

To make best use of large, commanding areas of color, try to set them off against other, more neutral, parts of the picture – here the black of the girl's hair, and her white shirt. You may be able to compose the picture so as to exclude discordant, distracting colors in favor of muted hues, such as the soft browns of earth – or of skin itself.

Sea and sky turn deep azure in dawn light. The dark color, deliberately underexposed, emphasizes the lights of the island temple.

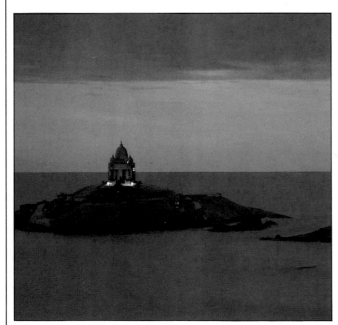

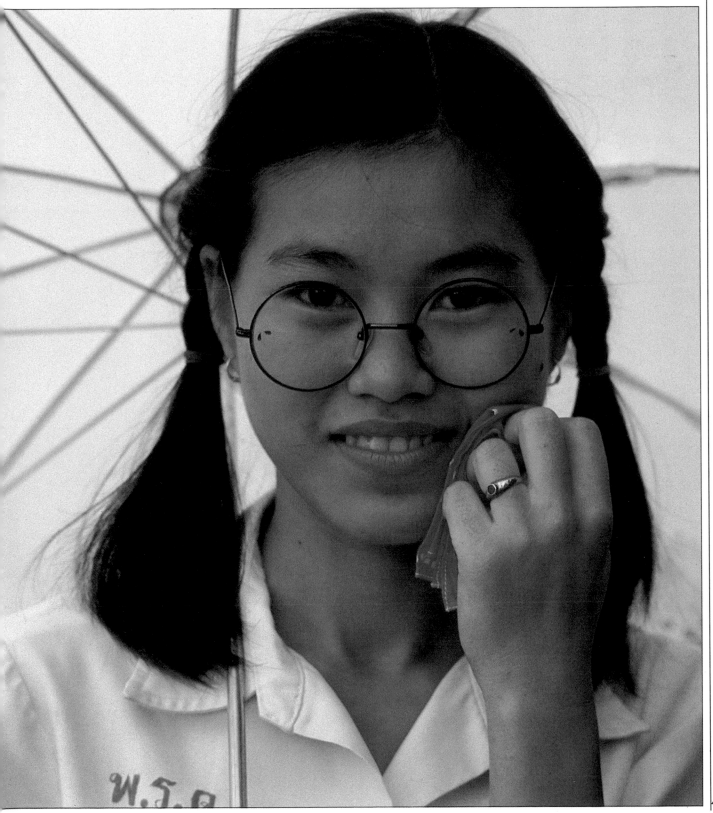

A yellow umbrella makes a vibrant background for this simple picture – a delightful rainy-day portrait. The light filtering through the fabric is soft and flattering, warming the whole image, and enhancing the tones of the girl's skin.

Limited color

Images that have very little color at all can some-times be extraordinarily evocative. Such nearly monochromatic pictures are expressive in a much quieter way than are most color photographs, but they often have a compelling simplicity and beauty. Not least, they draw our attention because they are relatively uncommon.

Two main types of monochromatic images are those in which the lighting or the prevailing weather conditions provide an overall draining or blending of colors, and those in which the subject itself has little variety of color. A landscape lit by weak sun, early or late in the day, will tend to have a predominant orange glow, especially if there is a haze or dust in the air. Rain, fog, mist, smoke – even pollution in industrial areas – scatter light and mute colors, reducing the color range of the most variegated subjects. You can sometimes use the glow of a fire or the color of artificial light to tint a scene with a single, overall color. One useful tip for enhancing the effect of a colored light source is to shoot toward it without a lens shade, so that light flaring into the lens spreads the color over the whole image, often producing attractive effects.

Subjects that are monochromatic in themselves are usually more difficult to find – unless you can take the picture at close range. As a general rule, the larger your subject, the more likely it is to contain a variety of colors. For this reason, a long lens with its narrow field of view is far more useful than is a wide-angle lens for limiting the color range. Finally, you can always underline the prevailing mood of an existing color range with a pale colored filter.

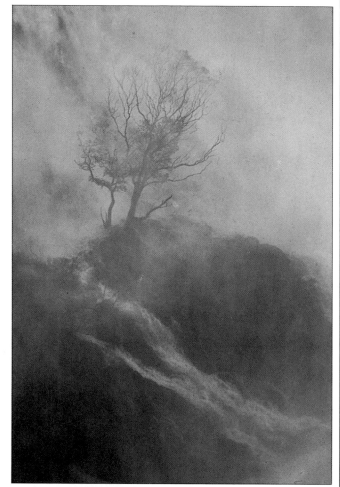

Soft spray, thrown up by the turbulent waters of Victoria Falls, scatters the light, suppressing true colors and rendering the whole scene in a subdued sepia tone. Only the skeleton of the tree stands out against the mist.

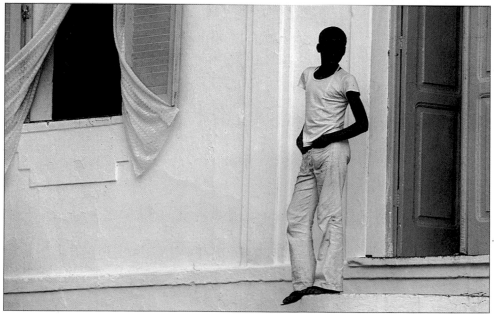

White and black tones can make subtle, effective combinations on color film. You need to develop your powers of observation to find a picture as simple yet expressive as this one.

44

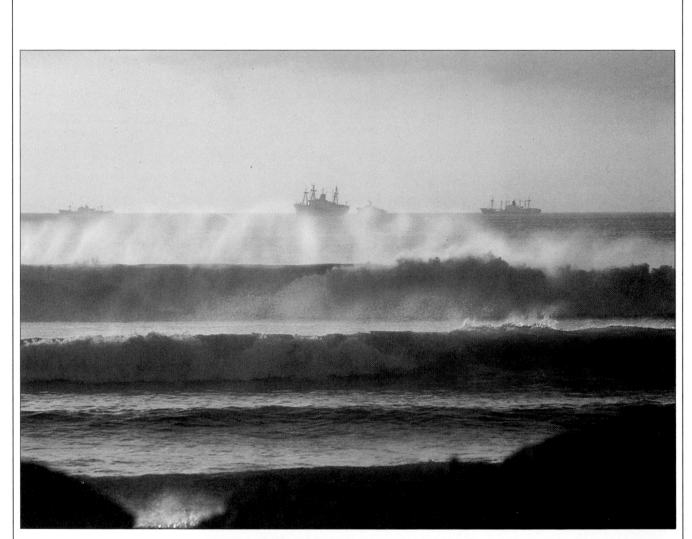

The golden sunset sky
suffuses the Cape of Good
Hope with glowing light.
A long lens has compressed
distance, bringing closer
the silhouetted ships on
the horizon.

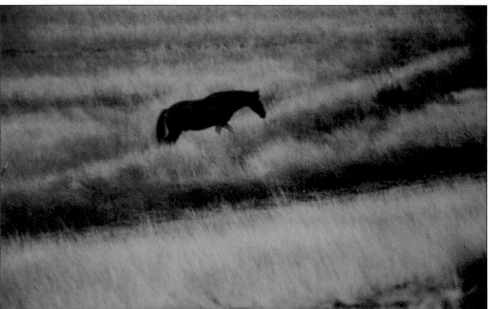

Ice-blue tones of the grass
form a soft backdrop to the
dark shape of the horse,
photographed in failing
light. When using a limited
color range, look for bold
shapes to provide contrast.

Color harmony

Although the way we see colors is highly subjective, most people agree that certain combinations of colors appear more pleasing or harmonious to the eye than others. Moreover, a restricted range of colors makes it easier to create a harmonious composition. A photograph made up of slight variations of a single color, for example, will obviously convey a sense of harmony. So will a mixture of one main color with various neutral shades — grays, browns, white or black. Combining two or more colors requires care. As the color wheel on the right shows, adjacent hues harmonize readily, but opposites contrast strongly. Thus, blues merge well with greens, whereas red and green compete for the viewer's attention setting up an optical impression of vibrancy.

However, there are exceptions to the general rule. Colors that are adjacent on the wheel may clash if they are very bright — a vivid red combined with a bright magenta, for example. Conversely, strongly contrasting colors can harmonize if their tones are either dark and muted or pale and washed out. For example, in the picture of the beach huts on the opposite page, subdued light has blended together a number of different colors. Think of the way the muted red and golden hues of an autumn landscape blend with the subdued greens. In practice, photographing colors harmoniously is a matter of composing your shots carefully to exclude any colors you judge may detract from the mood of the whole. If the hues appear too strident, you can also try waiting for softer lighting from a low or diffused sun to tone everything down.

Color wheel
Arrangement of the main color components of light on a wheel makes it easy to see how different hues work together. Here, the wheel is made up of the three primary colors — red, green and blue — and their complementaries — cyan, magenta and yellow. Half the circle has "cool" colors — green, cyan and blue — and half has "warm" colors — magenta, red and yellow. Colors that are close together on the wheel harmonize. But if tones are made paler, even the most contrasting colors blend — as can be seen here toward the center of the wheel.

Bright orange berries vary the mosaic of green leaves, but they do not detract from the natural harmony of the yellow and greens. You can include a contrasting color without disturbing the balance of the whole, if the contrasting area is small enough. Here the photographer stresses patterns of color as the subject of the picture.

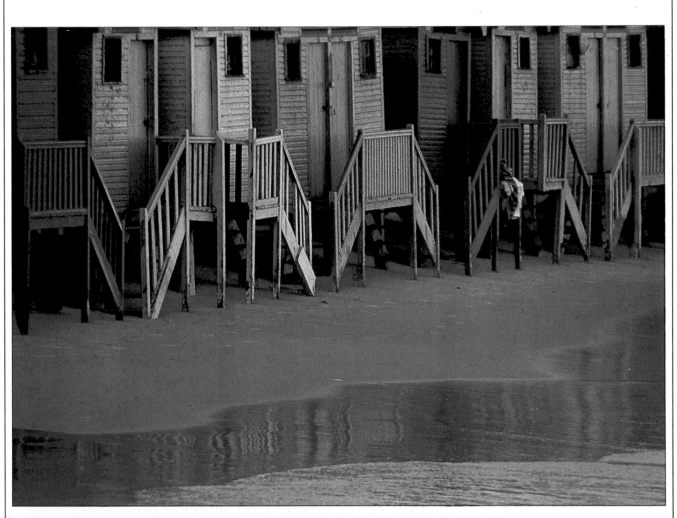

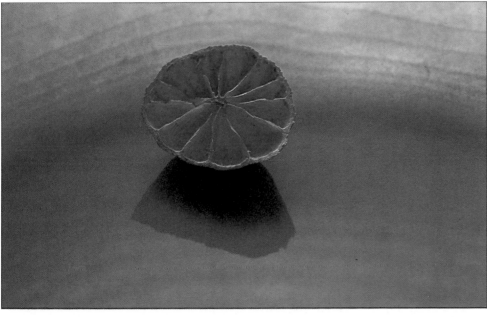

A row of beach huts at dusk creates a darkly harmonious color composition. In spite of the fairly wide range of colors, the tones are all muted and therefore convey a sense of tranquillity. The cool blue sand in the foreground helps to unify the shot.

Half a lemon, dried out by the sun, rests on a translucent painted plate. Although the lighting is bright and direct, all three of the colors blend together, providing a simple, but unusual example of warm color harmony.

Dramatic color

Just as some colors look balanced or harmonious when photographed together, others seem to contrast dramatically, and produce a bold, vibrant effect. You can use such dynamic combinations to inject excitement into a picture, to draw attention to a subject, or purely to create a strong abstract impact. Color contrast is most striking when you restrict your picture to two or three colors – any more than this and the effect will be restless.

The colors likely to produce the most striking contrast are those that lie opposite one another on the color wheel – the warm reds, yellows and oranges against the cool blues and greens, as in the photographs here. But what really determines how much two colors contrast is their relative brightness. Generally the effect is most dramatic if the two hues are equally bright. Pure color contrasts are often easier to find on a relatively small scale – by closing in on a shop window display, for example. When you have complete control over the ingredients of your picture, you can consciously set up bold color contrasts, as the photographer did for the fashion shot on the opposite page.

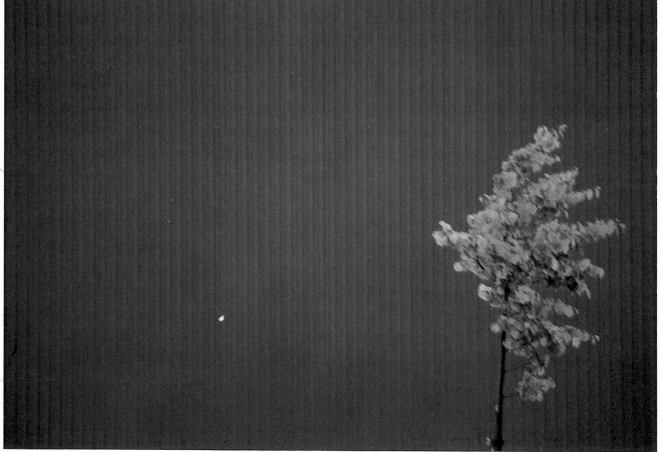

Ornamental plants often have colors almost as vivid as the artificial dyes and pigments in fabric and paint. At left, richly colored coleus leaves provide a perfect color contrast – red and green are opposite each other on the color wheel.

A delicate green sapling stands out crisply against the bright red fence, below left. The tree's fragility seems underlined by the strength of the red. A powerful yet very simple composition accentuates the dramatic contrast of colors.

A bright blue door makes the girl's yellow trousers look all the more vivid. The photographer has used the blue background to both isolate and frame the figure. And the picture shows how contrast increases when two light hues are juxtaposed.

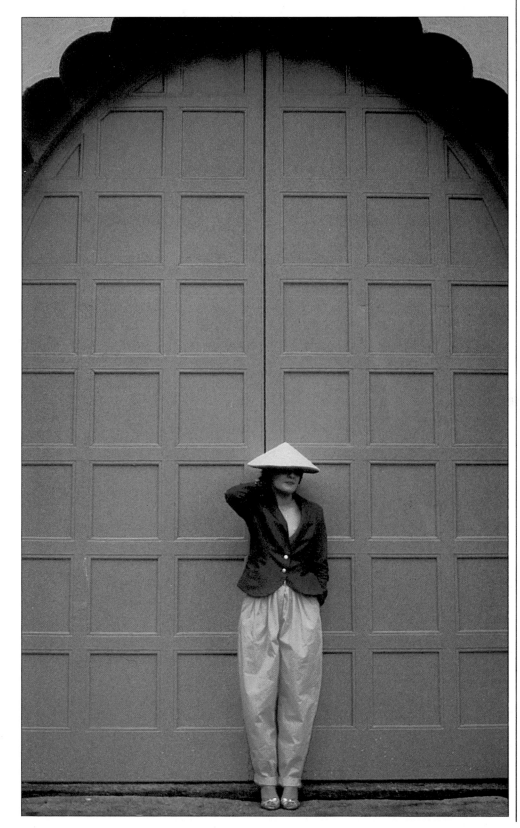

Restless color

When a number of rich, bright colors crowd one another in a scene, the effect is usually lively, and the tone of the image upbeat. Such images are unusual in the natural world, because colors there tend to be muted or combine in a generally harmonious way. You are more likely to find bright arrays of clashing colors at carnivals, flower markets, amusement parks, or cities at night – places full of the things we make or display.

Although strong colors in themselves tend to give us pleasure – and we respond immediately to colorful views – photographing such scenes successfully can be surprisingly difficult. The challenge is to capture the vitality without introducing a sense of confusion. Our experience of the scene itself is different from the view of the camera because the eye is selective, and introduces order by concentrating on those elements we find appealing. However, when translated into a photograph, the colored elements can assume equal importance and appear as a confused jumble. Even worse, the very profusion of color can make individual hues lose their force.

Because we apply more critical visual interest to a photograph, we expect to find balance or a sense of coherent composition in the way the colors are arranged. To work, compositions with a restless array of colors must be particularly well planned.

The simplest technique for exploiting the vigor of clashing colors is to close in and fill the frame with their richness – as in the pictures here of a pile of plastic cups and a carpet of brilliant autumn leaves. Moving in is also a useful technique for organizing the picture when a situation bursts with life and movement – as might a carnival procession, for example. Multicolored close-ups often provide a better sense of the excitement of the occasion than could a longer view. Try using a wide-angle lens.

Another way of achieving selection by framing closely is to use a telephoto lens from a greater distance. Do not be afraid to cut off parts of bodies or other elements with the edge of the frame. The lively night picture at the foot of the opposite page shows that you need only to concentrate on the pattern made by the colors in the viewfinder.

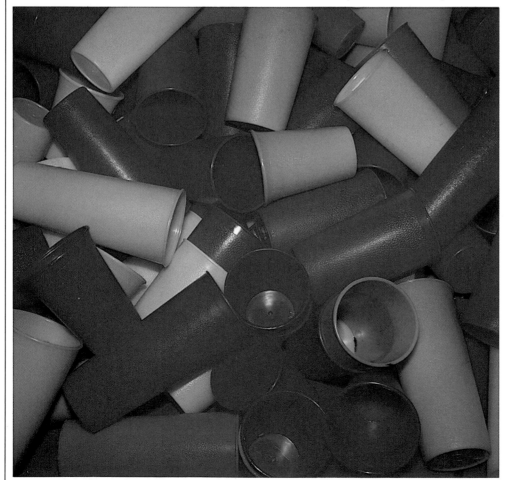

Plastic cups piled in a heap become almost overpowering when framed tightly to exclude the surroundings. Such synthetic colors often make brash, eye-catching images when seen together.

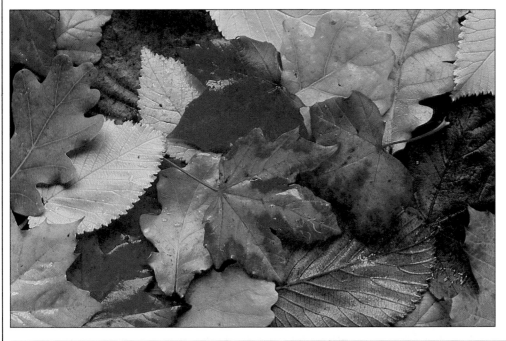

Fallen leaves form a pattern of russets, golds and reds. The colors of autumn sometimes seem subtle on the trees, but by raking them together and arranging them for the camera, the photographer exaggerated the contrasts and was able to produce an image with stronger color opposites than those usually found in nature.

City lights jutting against the deep blue of the night sky here produce an exciting combination. The choice of an aggressive upward view contrasts the red and green of the traffic signals with the yellow of the floodlit church behind.

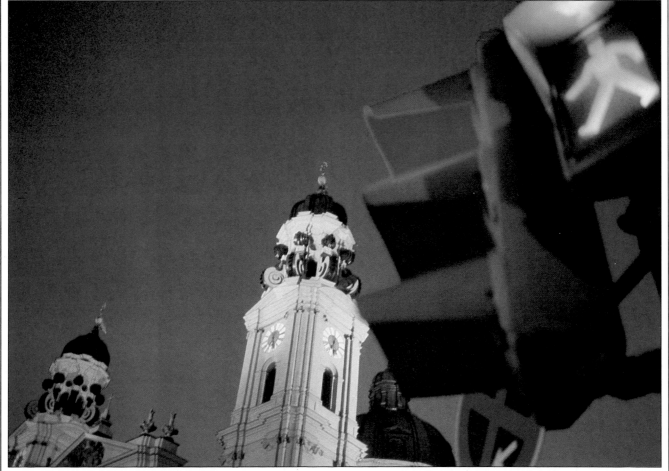

Using colored foregrounds

To use color creatively, you need to be able not only to choose colors that will work well together but also to control the position they occupy within the picture. Sometimes, a simple way of strengthening a composition is to use bold color in the foreground. If the balance is right, this can act as a kind of frame for the scene beyond, leading the viewer's eye into the rest of the picture and perhaps establishing a color key for the whole image.

Pure, bright colors create the most arresting effects. But you run the risk of overwhelming the rest of the picture if the foreground elements are too strong and sharply detailed. In the picture on the opposite page, the photographer overcame this problem by using a close viewpoint and a wide aperture to keep the bright lengths of material out of focus. When you want to retain detail in a colored foreground, make sure that the area really strengthens the picture and does not prevent the viewer noticing important background elements. Compose the shots so that the proportions of colors, or their alignment, balance the composition, as in the pictures near right and below.

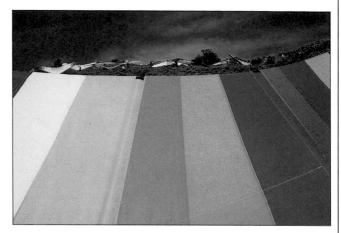

Colorful canvas stripes almost fill the whole frame, yet their receding lines lead us back to the hang-gliders in the distance. The photographer got down low to shoot across the wings of a grounded glider.

Shades of blue (below) link foreground and background in a picture that celebrates the power of pure color. The crane, tilting in the opposite direction to the bar of the red sign, just balances the foreground.

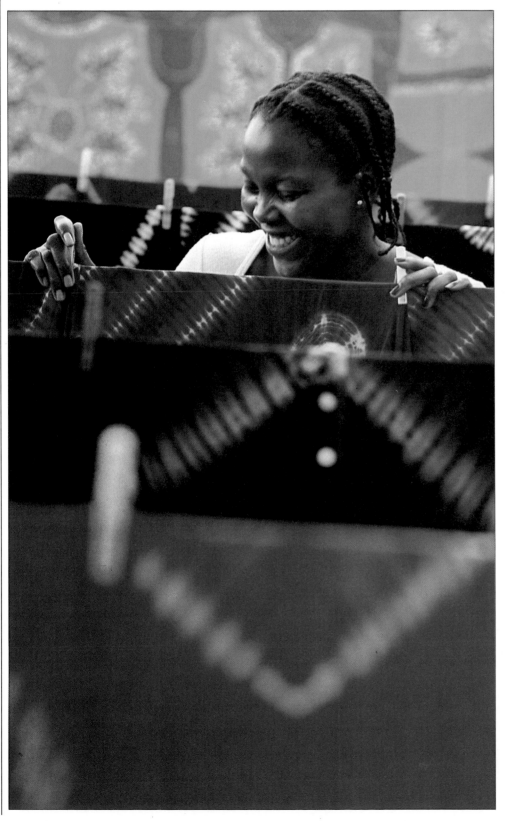

Vivid bands of cloth hung to dry enliven this picture, even though they are out of focus. The eye hurdles them and passes on to the smiling face of the woman. The bold strength of the foreground color balances the bright blue material in the background and together the two color areas serve to frame the head – the only element in the picture that is in focus.

Using colored backgrounds

Another important means of controlling color combinations in photography is by carefully selecting the background. Provided the background does not swamp the subject but sets it off to advantage, you can often allow an intense color to fill much of the frame. The subject itself will be emphasized if you choose a background that forms a strong contrast – a neutral tone for a brightly colored subject, a vivid background for a more monochromatic one such as the limousine below. If you have total control, a useful technique is to place a light-toned subject against a darker background to increase the sense of depth – too bright a background will flatten the entire picture.

Background colors strongly influence the mood of a picture, dramatizing the image if the color contrasts are vibrant, or suggesting tranquillity by color harmonies. Remember that you can control the intensity of a background somewhat by using selective focus to soften colors. Outdoors, an eye-level viewpoint may give too busy a background. The low viewpoint adopted for the picture on the opposite page sets the subject against the sky. Alternatively, simplify the background by getting higher. Sometimes a strong color area, such as a sunset sky, can itself become the starting point for a picture and prompt you to search for a suitable subject to set against the background.

A golden brown wall, occupying three-quarters of the picture area, gives this informal portrait strength without overwhelming the man.

The brilliant red inspired the picture below. Realizing its background potential, the photographer waited until a strong subject arrived – the sleek, black limousine.

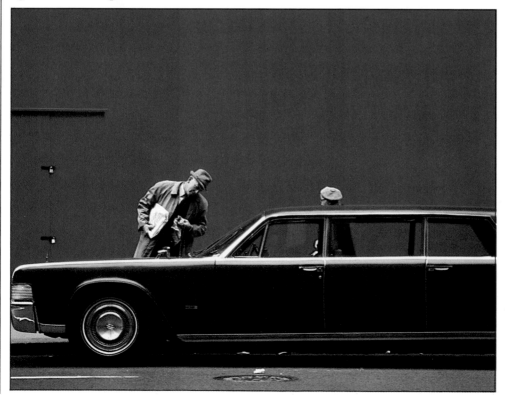

A cloudy blue sky can be striking enough to justify eliminating most of the foreground – the house merely balances the picture and provides a sense of scale.

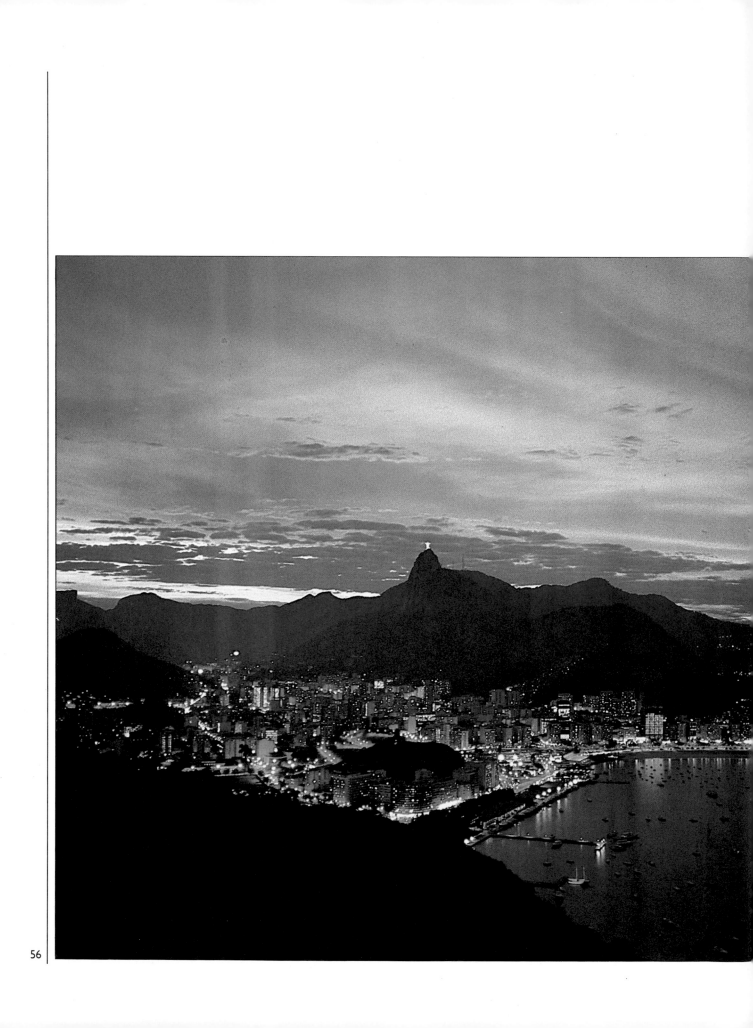

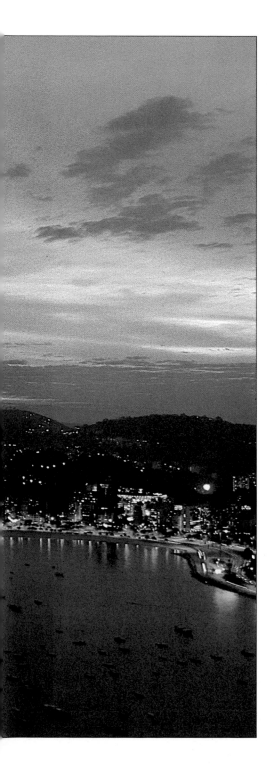

THE COLORS OF LIGHT

Colors are inseparable from the nature of the light that reveals them. Although midday sunlight and electronic flash combine the color spectrum in such a way that their light appears white, most natural or artificial light sources are tinged with color. Some forms of street lighting even look bright green. Objects illuminated by colored light sources are subtly transformed – an effect that is more noticeable in photographs than to the eye. If you take pictures of people when the sun is low in the sky, skin tones become warmer, whereas by the light of fluorescent lamps, faces may appear a ghostly shade of green.

Other qualities of light also affect the colors of objects in photographs. The direction and intensity of light determine the contrast in the scene, for example. And strong, direct light usually makes colors lighter, while more general, softly diffused light may actually produce purer and richer hues. Thus, the time of day and the weather strongly influence the colors in your pictures. Understanding these effects and identifying the color of a particular light source will help you to exploit the full color potential of the scene you are photographing. Certain lighting conditions also raise special problems of exposure. As a guide, captions to some pictures in the section that follows specify the film and shutter speeds, and the aperture size, for a difficult situation.

Rio by twilight reveals the variety of colors emanating from the many different light sources. Ebbing sky light reflects as blue on the water, while the last direct rays of the setting sun turn patches of cloud pink or orange. The city's fluorescent street lights shine green, with dots of orange from an occasional tungsten lamp.

Direct sun

Sunny days have pleasant associations for most of us, and not surprisingly, people take more pictures in sunshine than in any other kind of light. To some extent, the brightness and intensity of direct sunlight simplify photography, and give you extra flexibility. You can use small apertures for great depth of field, or fast shutter speeds to freeze movement. Alternatively, you can load the camera with slow film to take advantage of fine grain and detail, as in the striking picture opposite. Color accuracy is ensured because the light coming directly from a high sun is very close to white.

Making the most of the colors in the scene, however, may be unexpectedly difficult. Bright light can show colors in all their intensity – but only if the colors are perfectly exposed. The danger is that an area of bright color – the red sail of a boat, for example – will be lighter than the surroundings, and will look washed out in the picture because you have exposed for the darker average tones. To overcome this, take the exposure reading from the color area you want to look most brilliant, and if in doubt underexpose slightly – by a half stop or one stop. Sometimes, to show the strong color at its best, you will have to accept underexposure elsewhere.

To prevent strong reflected light from washing out colors, use a polarizing filter. This will cut glare from shiny objects such as cars or other reflective surfaces such as water. The picture below shows how the same filter can also control over-intense light reflecting from the sky, giving you a strong blue in the upper part of the frame.

White sails drift gently on a placid blue lake, and the direct sun picks out each accent of white with brilliant clarity. To capture the full scene in finely etched detail, the photographer used a slow, fine-grain film (ISO 25).

In vivid red and yellow, a trash can imposes a strong pattern of shapes and hues on a Florida beach scene. To darken the sky and make the bright colors of the hot plastic look deeper and richer, the photographer fitted a polarizing filter to the lens of his camera. When rotated to the correct orientation, such filters cut down glare and deepen the tone of areas of the sky that are away from the sun.

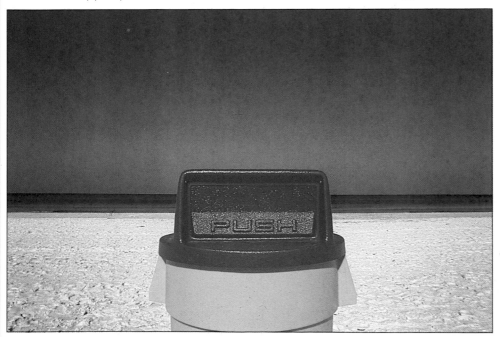

Low sun

Pictures lit by overhead sunlight conjure up impressions of hot, glittering afternoons, but the warm colors of low sun have more gentle connotations: morning light reminds us of the time just after dawn, when the sun's rays have yet to take the chill off the silent landscape. Sunset has a different, more romantic association — a lingering conclusion to a pleasant day.

Although our subjective impressions of morning and evening are quite different, these times of day are hard to tell apart on film. Low sun gives the same distinctive appearance to photographs taken early and late in the day. For a start, the raking light picks out textures and contours that are often masked when the sun is overhead. The long shadows are most obvious from above, so you can emphasize them by choosing a high viewpoint — as the photographer has done for the picture of the beach chairs on the opposite page.

The other distinctive characteristic of low sunlight is its color. The sun's rays on their oblique path through the atmosphere pass through more dust and water than they do at midday, and this scatters the shorter, bluer wavelengths. The redder, warmer colors that reach the earth give a rosy glow to pictures taken by their light.

We accept the redness of sunset and sunrise as natural, and often attractive, as in the picture here of the little girl by the poolside. But color film tends to over-accentuate the effect, and you may sometimes prefer to reduce the red tinge with a filter from the bluish Kodak No. 82 series.

Splashing in the pool at the end of a summer's day, this little girl is picked out in the warm colors of sunset. Far from needing correction, the reddish tones actually improve the picture. For a more formal portrait, or for subjects with a ruddy complexion, the warm cast might not be so flattering.

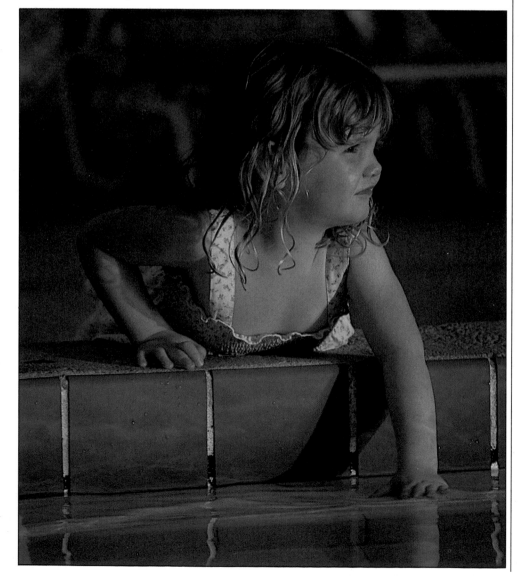

Drying paint on an artist's palette forms a pattern of color and texture when photographed from above. The photographer turned the board until the low sunlight fell obliquely across it, picking out the shining whorls of pigment.

Early morning light has emphasized the pattern and colors of beach seats (below). The photographer rose at dawn to take advantage of the long shadows, and to avoid the crowds that would have marred the perfect precision of the picture.

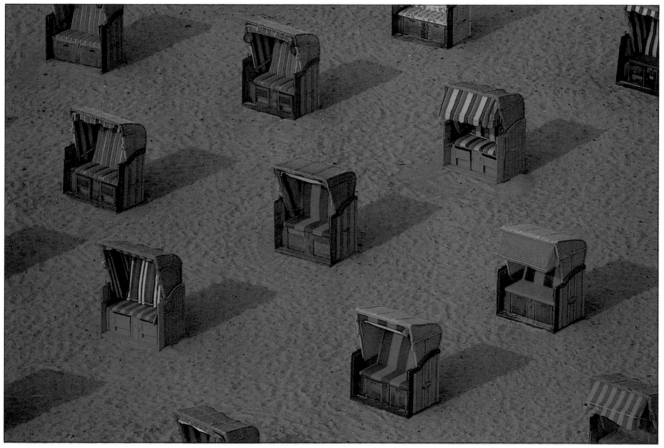

Backlight

The position of the sun always has a profound influence on the appearance of a photograph. But never so dramatically as when you point the camera directly toward the light source. This kind of lighting in a picture – usually called backlighting – works especially well with black-and-white film, because it produces highly graphic images that usually emphasize the outline and basic shape of subjects at the expense of surface texture, detail – and color as well. Nevertheless, you can use the technique to take color pictures of compelling simplicity.

If a subject is directly between the camera and the sun, the contrast range is likely to be so extreme that you will need either to overexpose the background or else to allow the shaded side of the subject – facing the lens – to become a dark silhouette. One exception is when the subject is transparent, allowing some light to pass through.

Because effective silhouette pictures in color rely on the color of the light source itself, morning and evening are the best time of day if you want to experiment. You may be able to use the warm, rich colors of sun and sky as the background. In the picture of the wooden pilings below, delicate pink light floods the whole picture as the water reflects the sky. To emphasize the subject's outline and retain the intensity of the background, take a meter reading directly from the sky, and perhaps increase the exposure indicated by one stop.

Although a silhouette is the normal effect of backlighting, the result is slightly different if the light source is just above or to one side of the subject. This produces a rim or halo around the subject, as in the picture of the girl below. You can make sure you retain the halo effect by taking a reading from the shadow area and then reducing exposure by two stops, and can experiment with the position and strength of the light to vary your effects.

Translucent subjects provide special opportunities for colorful backlit pictures. To capture the brilliant glow of the transmitted light, move in close and take a meter reading from the most important part of the subject – the petals of the yellow flowers, for example, in the picture opposite.

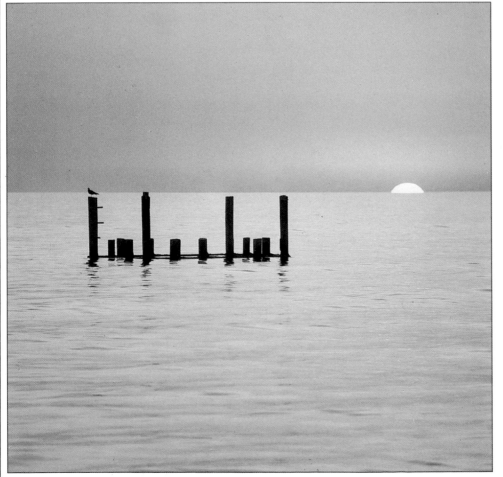

Outlined in sunlight, this window portrait would have been a silhouette but for the yellow light reflected from the girl's clothing. Look out for other similar reflecting surfaces to throw light into the shadows of a backlit picture.

Setting sun and high tide combine with mooring timbers in a spare, subtle image. By exposing for the background, the photographer reduced the seagull and its perch to their most basic and graphic outlines.

A vase of flowers glows with color against the dark background of a walled city garden. By taking the picture against the light, the photographer used the delicate translucence of the tulip's petals to brighten the yellow.

Diffused sunlight

You need to expose very carefully to bring out the brilliance of colors in direct sunlight, and to prevent them from becoming dissipated in glare and bouncing reflections. The pictures here show that colors often look richer in more diffused light. This is largely because contrast is reduced, making exposure easier to control. At the same time, the softer light helps to harmonize or balance colors — if that is your aim. And most important of all, diffused sunlight casts softer, less noticeable shadows. In portraiture, particularly, skin tones are thus recorded more accurately, and the whole image is less likely to be confused by the presence of deep, hard-edged shadows.

Light clouds and haze high in the sky diffuse light by redistributing the strongly directional rays of the sun across a larger part of the sky. The result is that shadows become less intense and their edges less sharp. Instead of being bright in the sun or dark in the shade, colors are brought closer together in tone. Provided the cloud cover is light, hues will retain their intensity. And, in the absence of hard shadows or reflected glare, the individual richness of the colors may actually increase. Because the key to showing any color at full saturation is accurate exposure, the reduced contrast between naturally dark and light colors will allow you to choose an exposure that suits both. The varied greens of landscapes can thus be recorded with equal brilliance in the muted light. And in portraits, you can more easily blend and balance flesh tones, clothing and background colors.

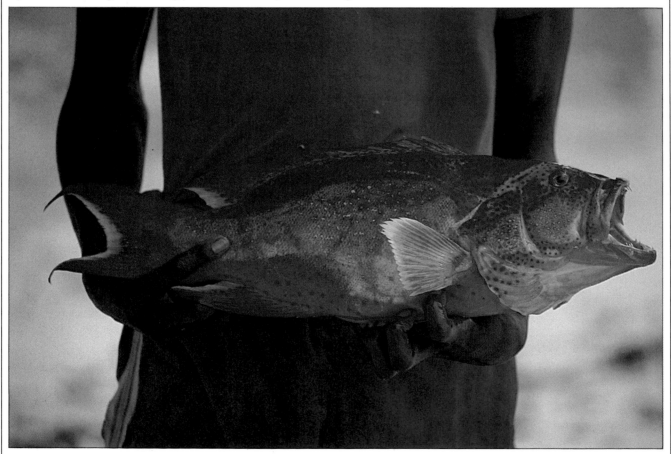

A red fish, photographed in Kenya, glows with an almost unnatural brilliance against the equally vivid colors of the fisherman's shorts and T-shirt. The hazy sun reveals the full saturation of all the colors, without the intrusion of dark shadows. And the light keeps to a minimum the glare from the shiny scales.

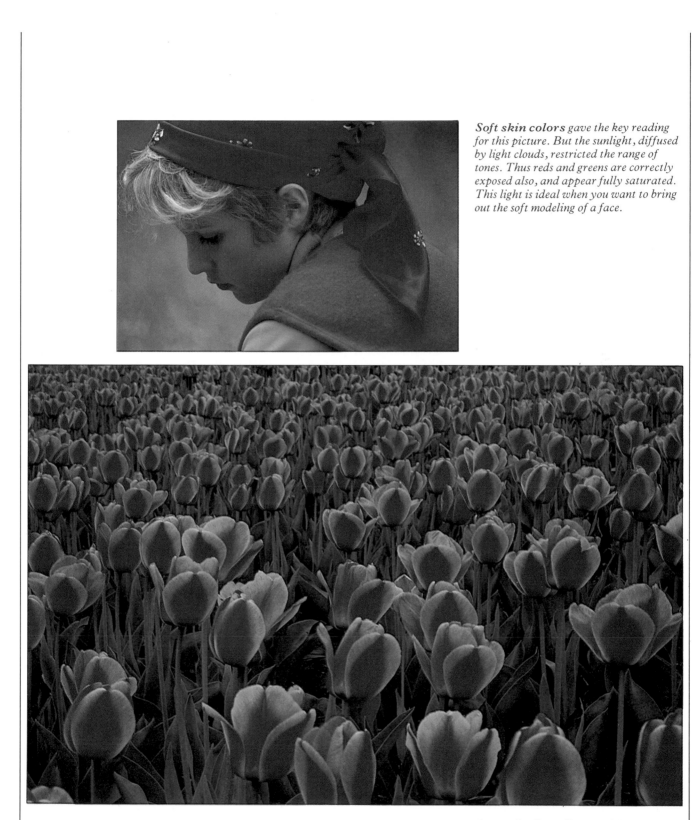

Soft skin colors gave the key reading for this picture. But the sunlight, diffused by light clouds, restricted the range of tones. Thus reds and greens are correctly exposed also, and appear fully saturated. This light is ideal when you want to bring out the soft modeling of a face.

A sea of tulips vibrates with color, every leaf, stalk and petal standing out in the soft light. Stronger sun might have made the flower heads gleam even more brightly, but the shadows created would have obscured the green parts of the plants, making them dark and underexposed on the film.

65

Haze, mist and fog

Photographs in dense haze, mist or fog produce some of the most delicate and subtle color effects. These conditions not only weaken sunlight, but also spread the light around the subject, and themselves become part of the landscape. Haze is made up of microscopic particles suspended in the air — common during long, hot spells and also in polluted areas such as cities. The droplets of water that constitute mist and fog are larger and more often found at higher altitudes, or near rivers, lakes, or the sea.

Haze, mist and fog all thicken the atmosphere, acting as a kind of continuous filter. The result is that intense hues are muted to pastel. At the same time, colors tend to merge into a narrower range, creating images as beautiful and fragile as the harvesting scene below. In extremely dense mist or fog, the colors of a landscape may become almost monochromatic; hence the effects of these weather conditions can be useful if you want to give a soft overall tone to an image or to harmonize colors that would jar with each other in brighter, more direct light. And the absence of distracting detail can help you to appreciate the compositional qualities of a landscape more easily.

The softening of color in haze, mist or fog becomes more pronounced with distance. The farther the subject is from the camera, the more simplified and delicate the image becomes, so that in a misty landscape, the different parts of the scene often appear to be arranged in receding layers of lighter and lighter color, as in the picture of mountain ranges opposite. Sometimes, you can emphasize the sense of depth this produces by choosing a viewpoint that includes strong foreground colors.

Remember that the effect of fog and mist are not always regular and predictable. In a breeze, wisps of mist trail around trees, rocks and hillsides, often linking hues or emphasizing the colors of clear areas. And in dense but localized mist, of the kind that often hangs over wetlands early on a summer morning, trees and other subjects can appear almost in silhouette if the sun is directly behind them. Light itself then supplies the only color, and in low sun, the scene may appear in delicate tones of orange or pink. You should look out for such unusual effects and exploit them by experimenting with viewpoint and camera angle. They open up marvelous opportunities for mood and atmosphere.

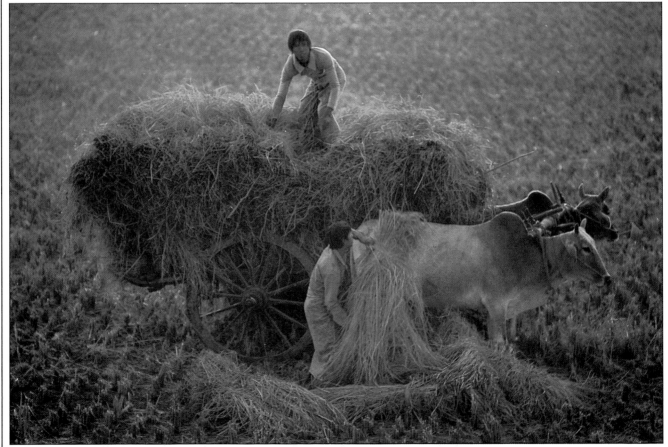

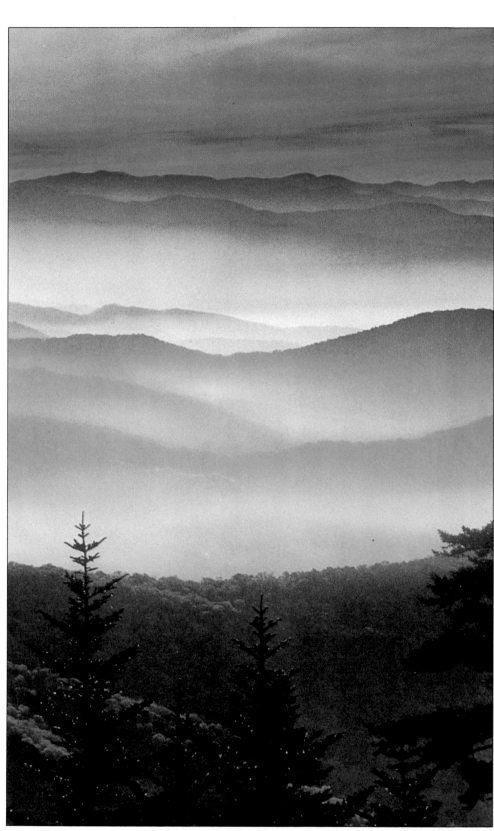

Late afternoon haze makes this Burmese agricultural scene almost monochromatic, turning everything a warm golden color. The stubble of the field enhances the feeling of shimmering heat, and the pale rim of light around the group reveals a perfect choice of exposure.

Receding mountains are reduced here into broad washes of color by early morning mist. This creates an imposing sense of depth as the planes of color fade from green to lighter blues. The whole image is given an ethereal quality by the orange light tipping the farthest ridges as the sun penetrates the mist.

Rain and storm

Many photographers see bad weather as a sign to pack away the camera and go home. By doing so, you may miss opportunities for really exciting pictures. Dull, overcast lighting can certainly drain most of the color from scenes and make everything seem drab. But often, light trapped beneath a lid of black rainclouds can give colors a dark, rich intensity never seen at other times. And although rain tends to soften and blur images, dampness often brings out subtle colors.

The spectacular brilliance of a thunderstorm, such as the one at far right, requires fast reactions – and, indeed, most storm-light effects are fleeting. The best chance of exploiting the vivid contrasts produced by a break in the clouds is to choose a high viewpoint. With a clear view over a wide area you can sometimes follow the bright trace of a shaft of sunlight moving across the landscape.

You do not have to wait until a storm is at its height to find dramatic light effects. A gathering storm can be equally impressive, especially in tropical climates, as the picture at bottom right shows. To preserve the relatively rich colors in the sunlight, and some sense of the impending darkness, be careful to avoid overexposure. You can emphasize the color through contrast if you take a reading from the sunlit area, and then underexpose slightly to make the sky look still darker.

The picture below shows that the clouds which produce storm conditions may themselves form powerful aerial landscapes, especially if you photograph them from a distance with a wide-angle lens. The most exciting cloud formations of all are the tall, billowing thunderheads that form on hot afternoons in the tropics or in plains country such as the American Midwest.

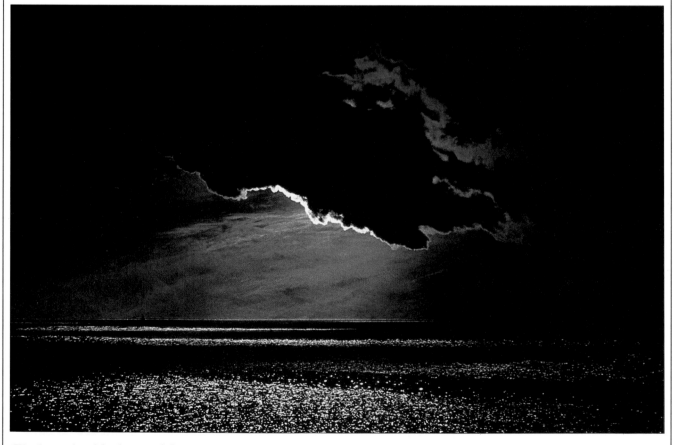

The lowering blackness of the storm cloud gives this picture a power that seems all the more intense because the light is so muffled. The photographer waited until the cloud just covered the sinking sun, leaving shafts of light piercing through to gleam on the sea.

Raindrops on a rose change its color to paler pink against a background muted both by the rain and by selective focusing. Delicate color effects can often be achieved just after a rainstorm, provided the light is good.

Searing backlight from an electrical storm produced this remarkable night shot of a train stopped on a bridge. The photographer put the shutter on a "B" setting for a time exposure that has captured several lightning flashes.

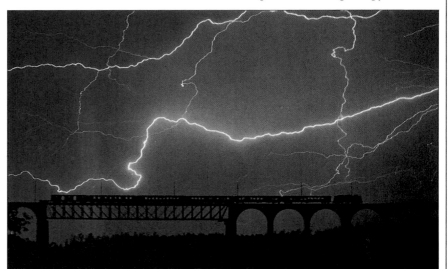

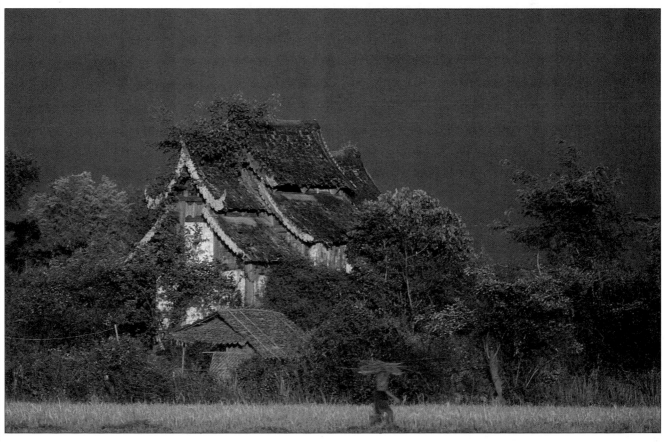

Glowing light bathes a landscape in South-East Asia moments before a gray sky releases a deluge of monsoon rain. In this rare and beautiful light, the contrast between light foreground and dark background heightens the color.

Dawn, dusk and night

Depending on climate, season and atmospheric conditions, the rising or setting sun can produce a remarkable range of flamboyant or subtle hues. At these times, the sky may be used as a richly colored backdrop to a foreground city or landscape, or may provide sufficient pictorial interest to stand as a subject in its own right. Often, in order to bring out details of colors and cloud patterns in the sky, you will need to expose for the sky itself, leaving foreground elements to darken. With this in mind, try to choose objects in the foreground that will make strong silhouettes – or that have enough illumination of their own, as do the city buildings in the picture below right. A telephoto lens can emphasize the size and color of a sinking or rising sun, or of the moon, when you want this to form the main subject, as in the photograph on the opposite page.

At dawn and dusk, it is not only the colors of sun and sky that vary from one moment to the next. The intensity of the light also changes rapidly. Therefore, keep rechecking your exposure reading every few minutes, and bracket exposures for safety. Because the light will be limited, if you are handholding the camera you will need a fast film, and a lens with a wide maximum aperture to allow a shutter speed fast enough to avoid the risk of camera shake. Often, time exposures are necessary, for which a tripod or other form of camera support is essential.

Cities at night are full of opportunities for colorful pictures – ranging from dramatic skylines to brilliant illuminated signs, multicolored window displays, or the patterns of light made by moving traffic. Many of the most successful night pictures are in fact taken at dusk, when the sky retains some color – and enough light for an exposure of perhaps 1/30 or 1/60 – yet street and domestic lights convey the impression of true night. In landscapes, the full moon itself can make an unusual light source for nighttime color shots. Contrary to popular belief, moonlight is white, not blue. Again, dusk is the best time for photographing the moon, because there will be enough light for a relatively short exposure. The moon moves more quickly than our eyes tell us, and if the exposure is longer than about a second, blur will begin to appear. In fact, the movement of the moon relative to the earth is such that it takes only about two minutes for the moon to cover the distance of its own diameter.

A neon sign, tightly framed, glows in luminous contrasting colors (above), emphasized by the use of daylight film. The exposure with ISO 200 film was 1/60 at f/4.

Ablaze with color, the radiant sunset sky creates a strangely surreal backdrop to the illuminated San Francisco skyline (ISO 400 film: 1/60 at f/5.6).

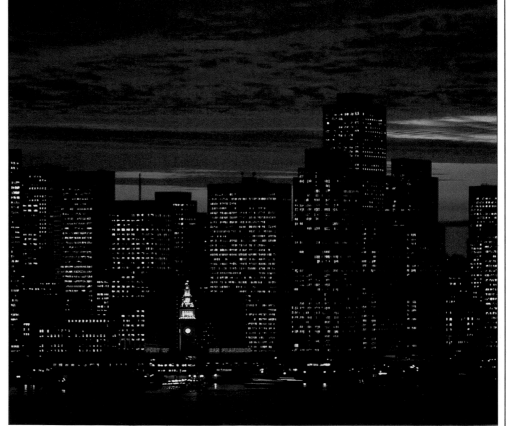

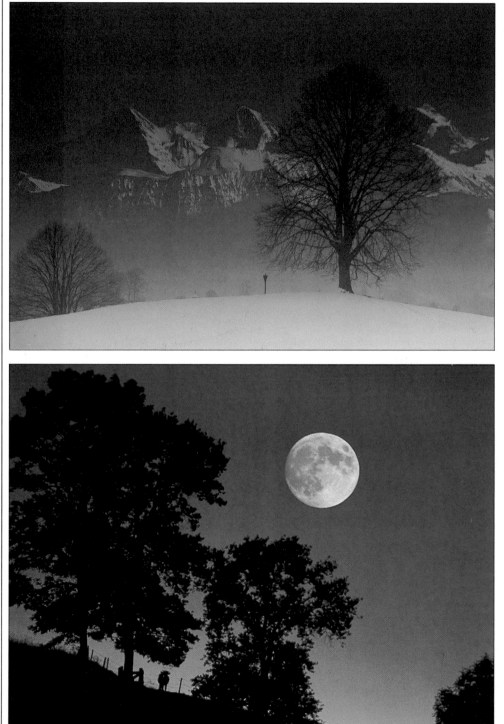

Pink light at dawn has tinted the distant mountain range, adding warmth to the cool blue of the sky and the snow. Dawn and dusk are marvelous times of day for shooting snow, seascapes, or any reflective subject that will pick up the color of the light (ISO 200 film: 1/250 at f/8).

The full moon, through a 400mm lens, stands out from the blue evening sky. At twilight, when it has just risen, the moon seems to loom largest in the sky. Enough light remains in the sky to show the hill and trees in silhouette (ISO 64 film: 1/60 at f/11).

Snow

Winter snowfalls create some of the most exceptional scenery, with marvelous opportunities for crisp color contrast. But you need skill to preserve both the pure whiteness of snow and its sparkling, crystalline texture. Calculating the right exposure is crucial – snow tends to look gray if underexposed, and featureless if overexposed.

The camera's meter will usually read from the highlights in snow, and indicate an exposure that compensates for the intense brightness. Thus, the result of following the meter reading may be a less brilliant picture than you want. To avoid this, open one stop more than the metered reading. If taking several pictures, bracket the exposures to make sure of at least one good result. Perhaps the ideal is an exposure that records the brightest areas of snow as fractionally less than pure white – darkened just enough to show a hint of texture.

The sparkle and crisp texture of snow are revealed best by sunlight from the side or from slightly in front of the camera. Being highly reflective, snow tends to pick up any surrounding colors, and especially the colors of the sky. This can produce beautiful effects early or late in the day when the light is pink or golden. In overcast conditions, a yellowish No. 81C filter helps to compensate for the overall blue cast. But on a clear day, when snow appears white in direct sunlight and a strong blue in shaded areas, you cannot use a filter without altering the purity of the white at the same time. If you are photographing mountain scenery, use an ultraviolet (UV) filter to cut down the overall blue cast caused by the scattered ultraviolet light at high altitudes. In order to enhance the deep blue of the sky, contrasting with the crisp white of the snow, you can use a polarizing filter.

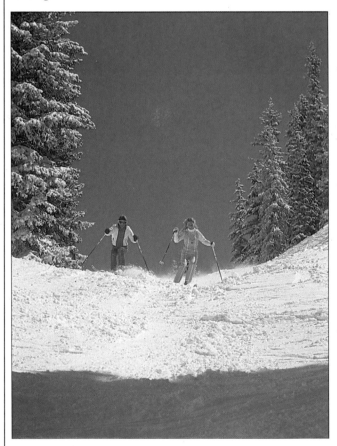

Two skiers in packed snow provide warm color against the coolness of white and blue. Using ISO 64 film, the meter reading was 1/500 at f/11, but the picture was taken at f/8 to retain the whiteness.

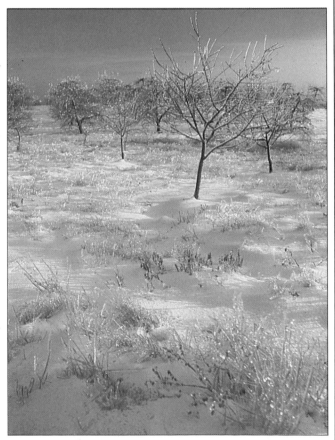

The golden light of a low sun early in the day bathes the snow with the warmth of the reflected color. Notice how the slanting light glints on ice melting as the temperature rises.

Shaded foreground snow,
*still reflecting blue light
from the upper sky, blends
softly with sky tinged by
the setting sun nearer the
horizon. Snow allows you to
make handheld exposures at
dusk even when little light
remains in the sky.*

A latticework of snow
*in a fence (below) creates a
pattern by breaking up the
bright colors of playing
children. Winter landscapes
are full of such opportunities.*

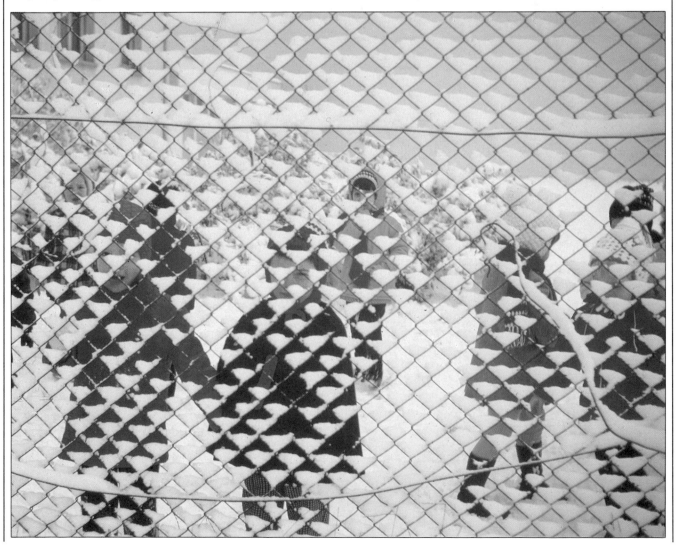

Tungsten lighting/1

A Balinese girl looks out from a setting of carved splendor. Tungsten lighting used with tungsten-type film gives the scene a golden glow; daylight film would have made the tones warmer (*ISO 160 film: 1/30 at f/2.8*).

While most photographs are taken in daylight, opportunities for color photographs of equal beauty and interest emerge when artificial light provides the main illumination. The most common form of artificial light for photography is flash, which has approximately the color characteristics of daylight. Often, however, room or street lights provide sufficient illumination for a long exposure with a tripod – or they may appear in the picture as an inherent part of the subject. These lights are frequently tungsten filament lamps, with a warmer color than daylight, showing as orange on daylight film.

For convincing natural results, you may want to correct the orange cast back to normal by using the techniques described on pages 24-25. On the other hand, you may use the orange successfully to inject more color into your pictures. As a general light source, tungsten provides an overall warm glow that is often attractive. In the same way, individual tungsten lights in a picture taken in very low light or darkness will show as points of orange or yellow light, enlivening the scene. Think about such color effects before deciding that you need to use a conversion filter or a film balanced to tungsten light.

Varied wooden surfaces create a rich interplay of tone and texture – the daylight film used records a delicate orange cast from tungsten room lights, producing an inviting feeling (*ISO 64 daylight film: 1/2 at f/5.6*).

Large cities are usually full of tungsten lighting at night, and even more so on festive occasions. The photograph on the left shows the Place de la Madeleine in Geneva, with a merry-go-round the center of attraction. The overall feeling of warmth in the colors is characteristic of tungsten light recorded on daylight film (*ISO 64 film: 1/8 at f/4*).

A highway at night gives opportunities to photograph spectacular tungsten light effects. At right, two main sources create contrasting patterns, the regular lines of the lights acting as a foil to the curving trails left by car tail lights during a long exposure (*ISO 64 film: 1 sec. at f/5.6*).

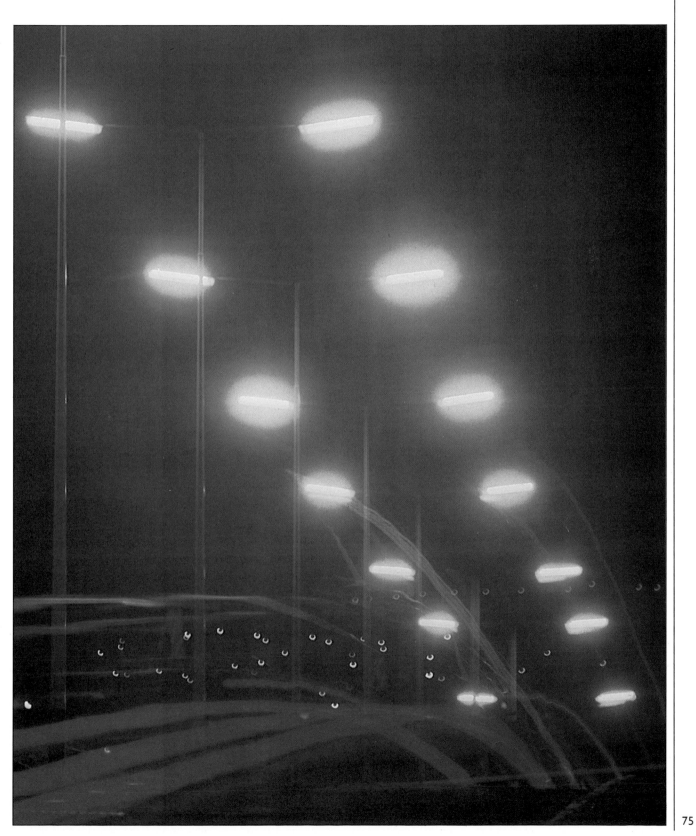

Tungsten lighting/2

Mixed lighting is characteristic of many nighttime photographs, particularly at dusk, when ebbing daylight may provide as much or more light than tungsten or other lights that have been switched on. While sometimes presenting tricky problems in terms of exposure or film choice, this kind of lighting also produces some of the most attractive color effects. This is particularly true when one source of light predominates in the picture while another provides contrasting color accents.

The basic rule for mixing tungsten and daylight is to decide which light source dominates, and choose a film balanced to that. Outdoors, just before nightfall, the main illumination comes usually from the daylight. On daylight film, the tungsten lights will appear orange, as in the pictures below. When there is less daylight than tungsten light, you could decide to use a conversion filter – or a slide film balanced for tungsten light – in order to show tungsten-lit colors more accurately.

The choice between daylight and tungsten light film becomes more crucial for pictures of interiors in which you need to use a mixture of daylight and room lighting. If daylight from windows predominates, and particularly if the windows appear in the picture, there is no need to change from daylight film. The warm orange of tungsten room lights will add to the atmosphere, as in the interior scene on the opposite page.

In the early evening, or if the windows are small, the situation may be different, with the main light coming from the room lamps. To avoid everything turning orange, you should use a tungsten-light slide film – or a No. 80A blue conversion filter. Light from the windows will appear in the resulting picture as a shade of blue.

If you are undecided about whether daylight or tungsten dominates, always opt for daylight film. The warm glow of tungsten light exposed on this film is usually more acceptable than the cold blue of daylit subjects recorded on tungsten film, and looks closer to normal experience.

A streetlight glows in gathering dusk – daylight film records most of the scene in its true colors, but tints the lamp a warm orange (ISO 200 film: 1/30 at f/2).

The fish stall is lit by daylight, but the fish seller is lit by tungsten. On daylight film, his face looks orange (ISO 64 film: 1/60 at f/5.6).

A hotel lobby in Monte Carlo is lit by tungsten lamps, but daylight floods in through the glass doors. On daylight film, the tungsten-lit ceiling looks a rich orange, suiting the opulent decor. With tungsten light film or a color filter, the ceiling would have appeared in true colors, but the entrance would have looked a chilly blue. The photographer rightly chose to use daylight film unfiltered (ISO 200 film: 1/125 at f/4).

A Palm Springs street is lit bright by tungsten shop lights of varying strengths. Here, the use of tungsten film adds interest by deepening the dusk sky (ISO 25 film: 2 secs at f/5.6)

Other artificial lighting/1

A tungsten lamp produces light by heating a thin coil of wire inside a glass bulb, but some other common light sources do not rely on heat. Fluorescent lights and other vapor lights such as sodium and mercury work instead by passing an electrical current through a gas- or vapor-filled tube. Light produced by the resulting spark nearly always has a distinctive color – for example, sodium lighting, which is widely used on roads and industrial premises, is yellow. Sometimes the color of vapor lights gives visual interest to scenes that might otherwise look mundane. But when you are using vapor lighting to illuminate other subjects – especially people – the color cast may simply look wrong.

Sodium and mercury vapor lighting produces effects on daylight film similar to those produced by tungsten lights, but the color casts cannot be eliminated in the same way. Whereas the light wavelengths of tungsten lamps range across the whole spectrum – but with a bias toward red – vapor lamps other than fluorescent tubes produce light of just one or two colors. Putting a filter over a camera lens can only remove colors, not add them. Thus, although you can filter out the excess of red

light from tungsten, you cannot put back the wavelengths missing from sodium or mercury light, whatever film or filter you use. The best thing to do is to accept the situation and make a virtue of the resulting color. For example, all the pictures here were taken on daylight film. In portraiture, where usually natural skin tones are important, you can introduce another light source, such as electronic flash, to light the foreground and counteract the color cast in the main area of the picture.

Fluorescent strip lamps differ from other vapor lamps, because their glass tubes carry a coating of phosphors, which make the tube glow with light in a broad range of wavelengths. Although this produces a light that looks white, all but the most expensive lamps are deficient in red or magenta, and pictures taken by their light have a greenish tint. The actual shade of green depends on the type of tube and its age. If you are taking a picture in fluorescent light, and color accuracy is important, you may need to make a series of exposures with different color compensation filters. But generally, a CC 30M (magenta) filter, or a special "fluorescent to daylight" filter will help.

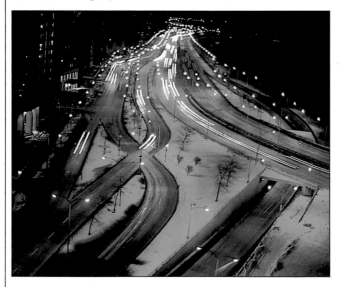

City streetlights usually are either sodium or mercury vapor lamps. In the picture above, the photographer used a long exposure with the camera on a tripod and took advantage of the striking color of mercury lamps to turn roadside snow into a turquoise background for the lights of the passing cars (ISO 200 film: 4secs at f/11).

A pool enclosure, lit by fluorescent tubes, seems to be suffused with green light. The tinge is seen most clearly where the lights shine directly onto the blue-gray wall. The effect produced is one of subterranean chill and eeriness (ISO 100 film: 1/60 at f/5.6).

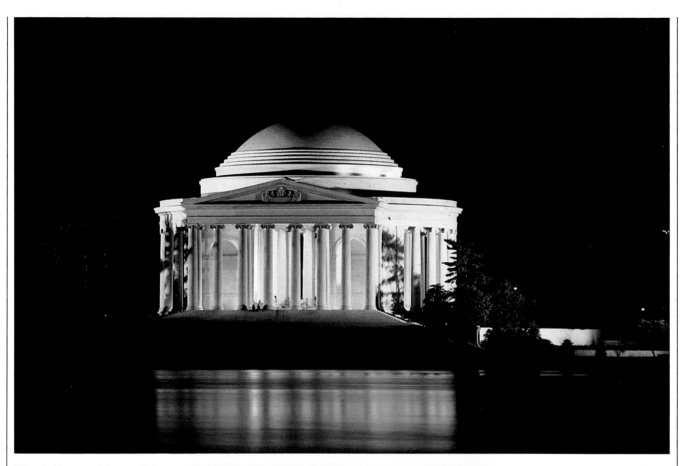

The Jefferson Memorial (above) appears the yellow color of its floodlights. To the eye, the building would have appeared much whiter, but complete color correction is not necessary to achieve an effective picture (ISO 400 film: 1/30 at f/2).

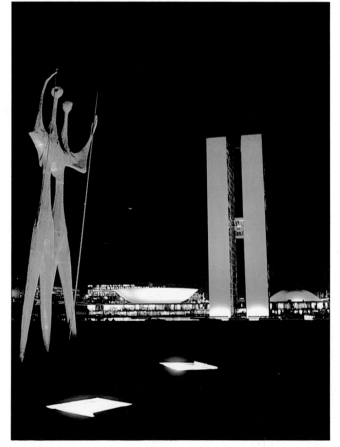

A statue in Brasilia glows an unearthly green in the light of mercury floodlights. Such monuments often look at their best by night, when the strange and upredictable colors of their lights show up strongly in photographs (ISO 200 film: 1/8 at f/5.6).

Other artificial lighting/2

In most twilight or night views of cities, every type of light vies for attention, producing a variety of lurid colors on film. Confronted with such color bonanzas, there is little point in attempting to balance the film to the light. Daylight film without filters will show greens, yellows or blues from vapor lamps, red or orange from tungsten, and the pulsing colors of neon lights – all mingled with whatever varied hues the last rays of the sun create in the atmosphere. The effects can be spectacular, and the shot on the right shows just the kind of drama a mixture of colors can create.

Occasionally you will be able to exploit these possibilities in a more controlled way. If you remember that vapor light is likely to produce a strong color cast on daylight film, you can contrast illuminated objects with the entirely different colors of the sky behind – as in the picture of a parked car below, which would have looked much less remarkable in ordinary lighting conditions.

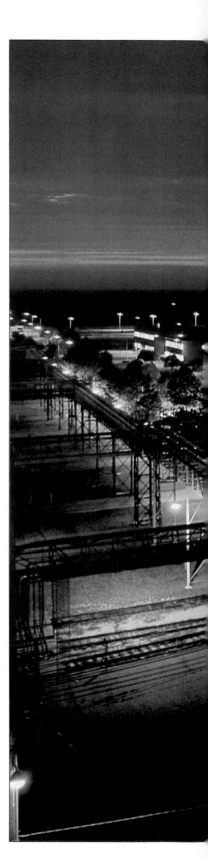

Multiple light sources illuminate this industrial complex. In addition to the setting sun, mercury and sodium vapor lamps shine on buildings and roads. Offices glow with fluorescent light, and tungsten lights from passing cars streak through the picture. Wisely abandoning attempts at color correction, the photographer took full advantage of the contrasts.

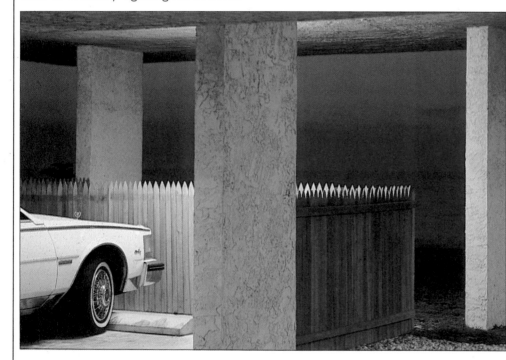

A beach-side parking lot shines with the luminous green of fluorescent strip-lighting. Against the deep pink of the twilight sky, car and blank concrete take on an eerie starkness. Although the artificial light looked white to the eye, the photographer anticipated the more striking color that film would show.

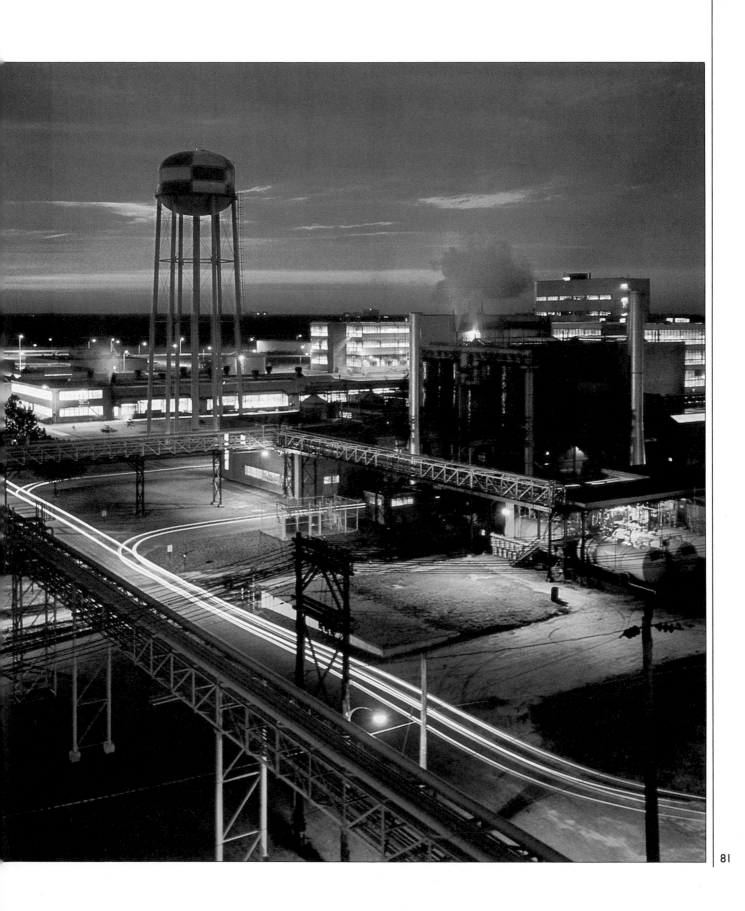

Flames

The light of flames from burning candles or oil lamps, matches or fires provides the most natural form of illumination other than daylight. Although light is unpredictable, flames create such atmospheric images that pictures lit by this source can be enormously rewarding. Most flames burn at far lower temperatures than do indoor lights and so produce light of a distinctly orange, even red, color. Photographed on tungsten-balanced film, flame-lit scenes look a natural pale orange and on daylight film, which was used for all the pictures on these two pages, the warmer orange cast still looks acceptable, because even our eyes generally perceive flames as red or orange.

If you are taking pictures of only the flames themselves, accurate exposure is not particularly important – overexposed flames still appear yellowish while underexposure simply intensifies the red. Such moving flames as sparks or fireworks look attractive both when frozen by a fast shutter speed or when allowed to trace streaks of light during a time exposure. Choosing an exposure to record both the bright flames and the subjects they dimly illuminate is more of a problem. Place the subject as near as possible to the flame to minimize the brightness range. And read exposure from the subject, allowing the flames to be overexposed if necessary. You are likely to need fairly slow shutter speeds, even with high-speed ISO 400 film, and because exposure will be difficult to measure accurately, bracket your shots. Do not be tempted to supplement the light – using flash to photograph people around a campfire, for example, can destroy the entire mood of the scene.

A blacksmith, his face glowing red in the light from the fire, forges a horse-shoe. Daylight supplements the flames, providing the general illumination for the smithy (ISO 400 film: 1/30 at f/4).

A row of houses, lit by a giant festival bonfire across the street, seems to be on fire as the flames reflect in the windows – an effect enhanced by the red light (ISO 200 film: 1/15 at f/2).

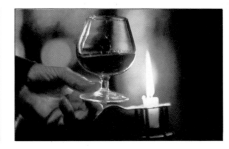

A glass of brandy, being warmed in a candle flame, makes an appealing still-life. The orange light creates mood, but is barely strong enough for an effective exposure (ISO 400 film: 1/30 at f/2).

A wood fire burns with orange flames in the snow. The scene is lit entirely by daylight, giving a very slight blue tint because of the overcast sky. The winter's day, stark trees and black dress make a monochromatic, even colorless, image, brought to life by the glow of the fire (ISO 100 film: 1/125 at f/8).

Fireworks *burst orange and white over New York harbor, contrasting with the fluorescent green of the floodlit Statue of Liberty behind. Among burning light sources, fireworks are uniquely varied in color (ISO 400 film: 1/30 at f/8).*

USING COLOR CREATIVELY

Most photography records the appearance of life, more or less unaltered by the imagination of the person who took the picture. In color photography, basic techniques such as exposing correctly or matching the right film to the light source are used toward this end. But having understood that color is attractive for its own sake, or has the power to move us, you may want to steer farther away from the literal representation of things. Often, by breaking the rules you can change the image that appears in the viewfinder and make a picture that will surprise the viewer – and perhaps yourself as well.

Some of the pictures on the following 16 pages show colors that are blurred, streaked by movement, or so isolated from their context by a close-range camera position that they make no literal sense. In others, reflections show subjects distorted beyond recognition. And in still others, filters have fragmented the colors of a scene, or introduced new and unearthly hues. Used skillfully, unorthodox techniques can allow you an artist's freedom to produce images of original beauty – patterns in which the colors do not define objects but serve your own creative purpose.

Condensation running down a window turns the image of the sun to the glittering texture of iced orange. Such a picture has no easily recognizable subject – our simple enjoyment of the color is more than enough.

85

Color and movement/1

Vigorous colors can add zing to action pictures frozen by fast shutter speeds – for example a ski racer in red angled against a wall of blue ice. Less obviously, perhaps, movement recorded with a slow shutter can produce color effects of a unique and subtle kind. Colors blurred or streaked across the film have a lightness and fluidity all their own. And you can use movement to separate colors altogether from subject matter, and form abstract patterns of lines and swirls.

Some of the fun of streaking color in a photograph lies in the uncertainty of the final image: you have to take some chances with this technique. However, you can exercise choice over the colors of subject and background, the speed and rhythm of movement, and the length of exposure – all of which have a bearing on the result. For the most dramatic results, choose a light colored or illuminated subject with a dark background. The faster the subject is moving – and the slower the shutter speed – the more the colors will be diffused and streaked. Alternatively, you may be able to find a strong, static color in the background and contrast this with a moving subject that is softly blurred.

Lines surging upward in a modern building (right) seem to pass through a descending figure. Having spotted the composition, the photographer set a slow shutter speed and waited for someone to arrive. The solid bars of color in the background emphasize the muted hues and blurred shape of the dematerialized figure.

Deckchair canvases billowing in the breeze, stream with fluid colors (above). The photographer used a wide aperture to obtain a shallow depth of field, so that only the middle chair is in focus.

A fairground in full swing throws out disembodied loops of colored light against a deep night sky (below). The picture's drama comes from the brilliance and whirling motion of the subject, combined with the still, dark background.

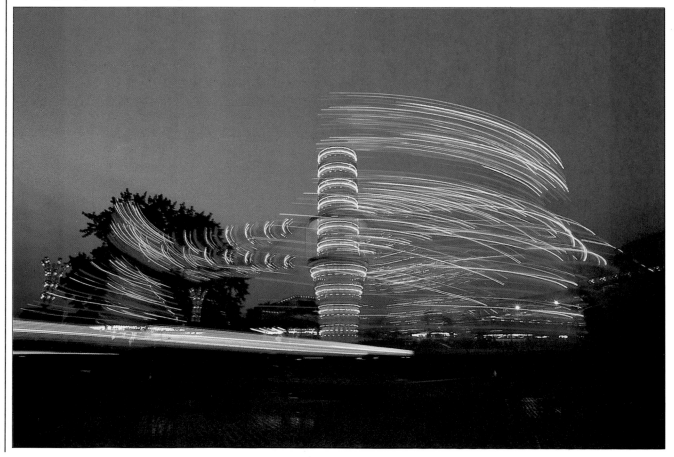

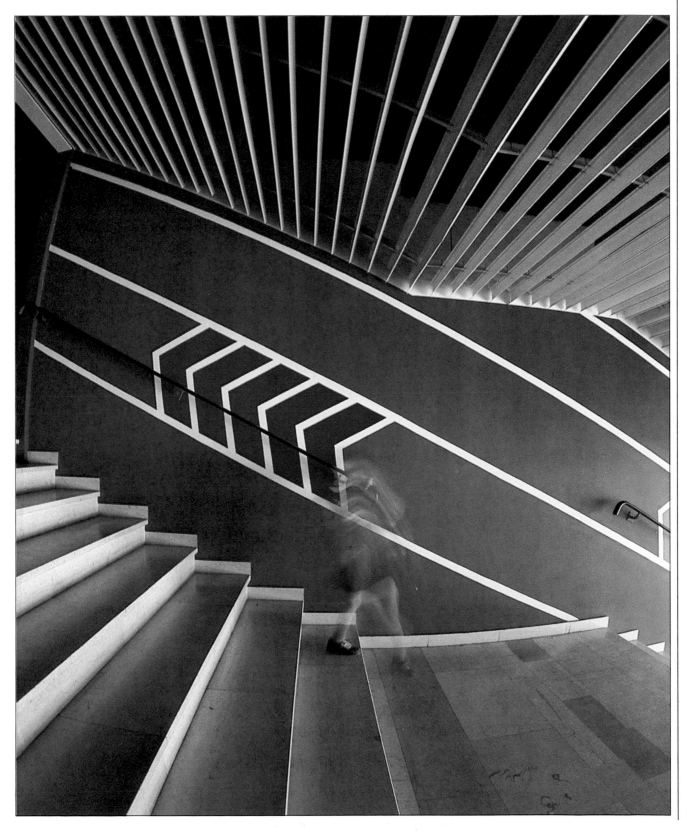

Color and movement/2

In addition to blurring moving subjects with a slow shutter speed, you can introduce streaks of light and color into your picture by deliberately not keeping the camera steady. A long exposure will still be needed – perhaps 1/4 to a full second. Simply loosen your grip and move, shake or jar the camera during the exposure. Different movements will give smooth streaks, abrupt angles or graceful swirls. However, anticipating the final results can be difficult and you must be prepared to experiment.

Deliberate movement of the camera can be used with both static and moving subjects. If your subject is passing across the frame, you will need to pan the camera to follow the movement. At the same time, try giving a slight jerk or even twist of the camera. With luck, the subject will retain a recognizable shape but be surrounded by liquid color, as in the picture of a jumping horse below.

An alternative way of breaking up the colors in a picture is to use a zoom lens and operate the zoom control during an exposure of about 1/4. The resulting effect of streaks radiating from the center of the image can give a vivid impression of movement, even when the subject is stationary.

The lights of Hong Kong skyscrapers (above) shoot into darkness like exploding fireworks. From a height, the photographer focused on the buildings across the street, then changed the zoom setting of the lens during exposure.

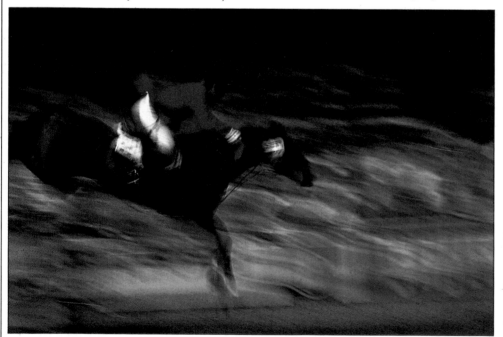

A horse and rider clear a jump against a backdrop of swirling color. Apart from following the movement of the horse with a panning technique, the photographer shook the camera to add fluid waves to the streaking.

White water bursts toward the camera as a kayak makes a difficult turn. Rather than using a fast shutter speed to freeze the movement, the photographer moved the zoom control during the exposure to increase the sense of energy.

Abstract color/1

You can give your pictures a striking abstract quality quite easily by exploiting bold color areas. All you need to do is to frame the subject so that colors rather than recognizable forms are emphasized.

A good way of making color abstract is to exclude part of the subject. We identify things largely by their outlines and the context in which we find them. Isolated by tight or unconventional framing, objects appear as a two-dimensional arrangement in the picture. The effect of the yellow dress opposite was achieved in this way. By cropping out the girl's head with the frame, the photographer has removed the obvious center of attention and concentrated on the composition as an arrangement of colors.

Alternatively, you can tilt the camera so that the subject, seen from an unusual angle, becomes less important than the colors. You can even try taking the picture with the subject deliberately out of focus to make the shapes less distinct and more to be enjoyed as areas of color.

Lighting is an important factor in emphasizing color at the expense of literal representation. Flat light on an overcast day can be used to give a two-dimensional effect because there are no shadows to throw objects into relief. On the other hand, direct sunlight, provided there is no glare, can illuminate colors and bring out strong contrasts between them, producing strikingly vivid effects.

An inflatable play space provides the setting for a boldly abstract composition. The photographer framed the scene to balance the three strong colors of the translucent material and has excluded any details that could act as reference points to help interpret the subject.

91

Abstract color/2

Color patterns, formed by natural and manufactured objects alike, make fascinating subjects for abstract photographs. As with any abstract image, the key to a successful composition lies in framing to eliminate unwanted details.

Anything assembled in a series — panels in a fence, bridge girders, or a row of soldiers — forms a pattern, and tends to flatten the picture. Subjects containing strong lines and only a few bold colors make the most effective images. With an open pattern, as in the photograph of childrens' swingboats opposite, the background can become part of the design.

A diagonal viewpoint often strengthens the sense of pattern — particularly if you use a telephoto lens. By giving an impression of foreshortening to the image, telephoto lenses produce pictures with a two-dimensional character — ideal when you want to emphasize patterns of color — as the picture below of a military band demonstrates.

A military band makes a dense color pattern dominated by the red and black of the soldiers' uniforms. From this distance, the ranks of guardsmen appear closer together than they really are – an effect that the photographer managed by using a 300mm telephoto lens to fill the frame with pattern.

Playground swings impose an intricate lattice framework on the merging hues of sand, sea and sky behind. Having moved around the subject in order to find the most effective composition, the photographer closed in from a diagonal viewpoint.

Finding color in reflections

Reflections – found in all kinds of settings, indoors and outdoors – offer the photographer particularly unusual color effects. Even a mirror gives back a subtly changed image of a colored object, and less faithful reflective surfaces can make colors appear to flow, swirl or bend. Just a slight unevenness in a shiny surface – such as ripples on water – will alter and distort a reflection. The patina of time-worn brass, gold or tarnished silver will overlay a reflected image with added color and texture. Chrome, a highly reflective surface, produces clear, bright images, but unusual effects are still possible because the curved chromework on cars and motorcycles strongly distorts anything reflected.

Because colors are usually muted when reflected, you will get the most vivid effects in bright lighting. If morning or afternoon sun illuminates buildings on one side of a river, leaving the water in shade, reflections viewed from the opposite bank are far more intense than they are on a cloudy day, when the entire scene is uniformly lit. However, sometimes an effect depends on soft, diffuse lighting – as in the sunrise picture below, in which an expanse of still water echoes the soft colors of the scene.

To photograph reflections on a small surface, for which a close camera position is necessary, you can use a wide-angle lens or a small aperture to get sharpness in depth. Alternatively, focus only on the surface: the reflection will then appear as a blurred wash of color. It might seem that the reflecting surface and the reflected image would always be equally in or out of focus, but for focusing purposes the image is farther away – light has to travel from the subject to reach the reflecting surface.

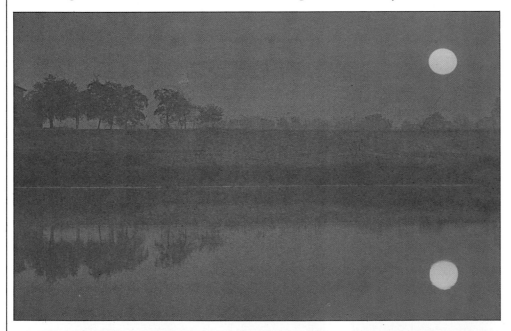

A lake mirrors the delicate hues of a pastoral landscape at sunrise (left). The glass-like surface of the water gives a reflection with only slight distortion, so that the effect is of a twin image.

A city street, slick after rain, reflects lights as a haze of colors (below left). By focusing on the surface of the road near the camera, the photographer has added to the soft, blurred effect.

A brass plaque in London adds its own mellow tones to the red reflection of a passing bus (below). The photographer focused on the plaque and waited for the bus to appear in view.

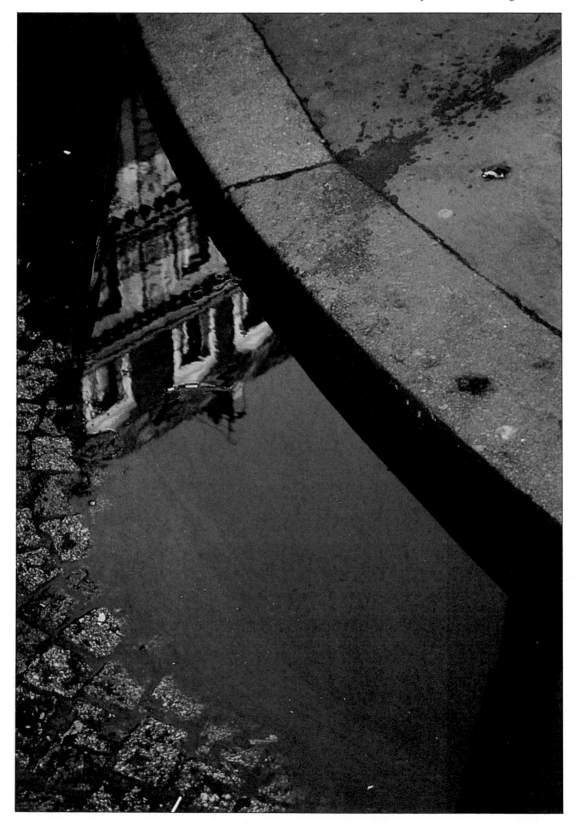

A small puddle beside
a cobbled street reflects
part of a sunlit building.
Strong lighting and a well-
judged angle give clarity
and definition to the image.

Color in close-up

Moving in extremely close can exclude distracting details and emphasize the strong colors to be found in relatively small parts of many subjects. You can even fill the picture area with patches of color so tiny that they would normally go unnoticed. To move in very close you need special accessories, such as inexpensive supplementary lenses, a macro lens or a set of extension tubes. These allow you to achieve tight, graphic compositions in which the colors almost seem to leap out of the picture.

Manufactured items often contain strong dyes that are particularly vivid in isolated close-up. The little pencil sharpener below is an example of the way that, with careful composition, an ordinary object can take on a significance and interest that would never be evident to the eye. In nature, too, colorful subjects can benefit from close-up treatment. Few flower heads are big enough to fill the frame at a normal distance. But by moving in to concentrate on details rather than recording the overall appearance, you can isolate the vibrant relationship between colors or give emphasis to a rich single color. The purple flower below would never have looked so pure and bright in color had its full shape been included in the picture. The strongly three-dimensional shape of flowers can be difficult to keep in focus because of the limited depth of field in close-up photography. This is not a disadvantage when your aim is to exploit only one color rather than to achieve the sharp clarity of botanical illustration. However, if you are photographing the intricate, multiple color patterns of plants or insects, when the sharp edges of the color areas are vital to the effect, you need to use an aperture small enough for the whole subject to be in focus.

A characteristic that is worth seeking out in nature is iridescence. The wings or carapaces of certain insects shine with a rainbow-like spectrum, which changes as the insect moves. Iridescence is also found in the feathers of some birds, perhaps most spectacularly in the peacock's, as shown in the photograph on the opposite page.

A butterfly wing (above) is seen as an intricate texture of scales when photographed at life size with a 50mm macro lens. Such close-ups of nature can reveal bold, even extraordinary, color patterns and markings.

The vibrant petals of a flower fill the frame with richly saturated color (above). Including only the center of the bloom has restricted the color range for a concentrated effect, achieved with a macro lens.

A red pencil sharpener contrasts startlingly with a green background (left). By closing in with an extension tube, the photographer made a strongly graphic picture from a small, everyday household object.

A peacock feather (right) shimmers with iridescence in a picture taken by fitting a supplementary close-up lens over a normal 50mm lens. The area of dark blue was carefully included to set off the shining lighter greens.

Special filters for color/1

The most direct way of manipulating the colors of a photograph is to use a filter over the lens. Most filters are designed to make technical adjustments – for example, to match the light to the color balance of the film in the camera. But many filters are now available that have a different purpose: to create dramatic images by altering the existing colors or by revealing hues that were hardly evident before.

The most basic filters of this type simply give the image an overall color tinge. Pale-colored filters have a subtle effect, modulating the colors in the scene and perhaps exaggerating a dominant hue. More strongly colored filters can influence every part of the image, creating entirely new and even

unrealistic colors. The shadow of the tree below has been bathed in lurid and mysterious color by a deep green filter, making the picture look like a night shot even though it was taken in daylight.

Some colored filters have only half their glass or plastic tinted, with a smooth transition from the color to a clear part. Known as graduated filters or half filters, these can be rotated, allowing you to color whichever section of the image you choose. Often, you can use them to tint the sky while leaving the rest of the picture unchanged. For example, the colors of sunset can be added to a daylight scene, as in the beach photo at right, where two graduated filters have colored different parts of the image.

A tree's shadow falling on a rough stone wall made a strong and interesting image but one that lacked color, so the photographer used a deep green filter. Daylight seems transformed into a strange artificial glow, with the green suffusing every part of the powerful image.

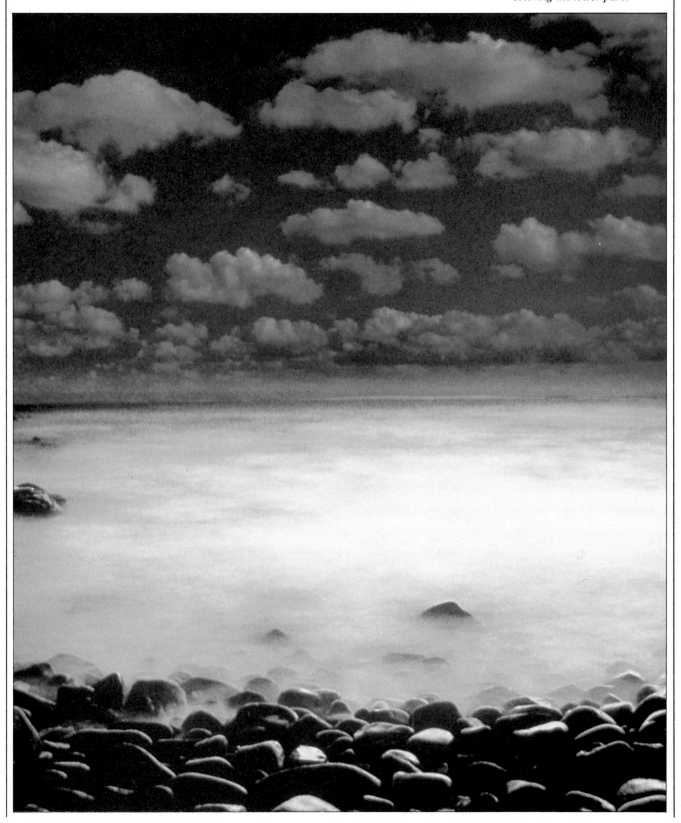

Pink and blue have been intensified in this simple beach scene by graduated filters – a magenta one rotated to tint the sky and a blue one coloring the lower part.

Special filters for color/2

Some filters that have no color in themselves can have dramatic effects on the way colors appear in photographs. Instead of modifying the color of the light passing into the camera, they cause a controlled deterioration of the image. For example, diffusion or soft-focus filters use various kinds of mat surfaces to dull a picture's sharpness very slightly, so that details are obscured and the colors merge softly into each other. Mist and fog filters change the image in a comparable way, but they have a much stronger effect. As their name suggests, they introduce a misty appearance, spreading out the color of the bright parts of the picture. With an appropriate subject, this hazy look can add a nostalgic or romantic feeling to your photographs – as in the picture of the girl in a landscape below.

Starburst and diffraction filters conjure up quite another mood – one of vibrancy and excitement. They are etched with varying patterns of grooves that can have different effects. A starburst filter creates a brilliant star from each bright point of light in the image. The number of points in each star depends on the filter. For example, in the picture of the neon sign at top right, the photographer used a two-point starburst filter. Diffraction filters go one step farther: with surfaces covered by a complex grid of minute grooves, they split the rays of the star into a rainbow-like spectrum.

A girl in a landscape seems surrounded by a soft, hazy, almost dreamlike atmosphere, created by a mist filter that also spreads and emphasizes the pink of her dress.

Neon dancers gain extra sparkle from the grooves on a starburst filter (left), which caused the colored lights in the picture to streak across the image as brightly ghosted lines.

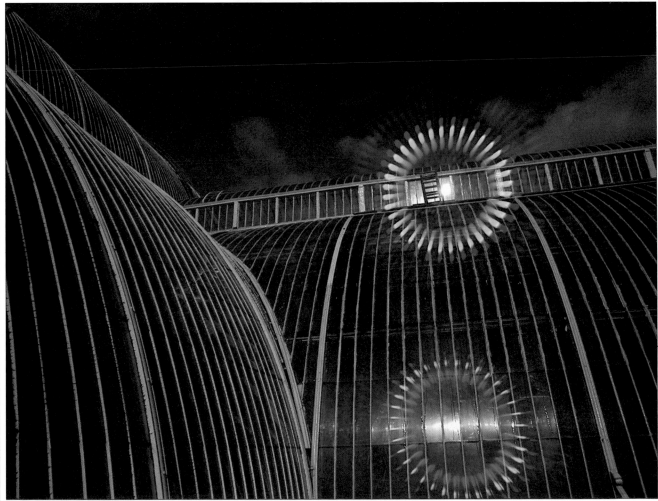

A huge greenhouse gleams in the sun. The photographer used a diffraction filter to create colored halos around the points of light caused by the sun's reflection.

Glossary

Aperture
The opening in a lens that admits light. Except in very simple cameras, the aperture can be varied in size to regulate the amount of light passing through the lens to the film.

Backlighting
A form of lighting where the principal light source shines toward the camera, and lights the subject from behind.

Bracketing
A way to ensure accurate exposure by taking several pictures of the same subject at slightly different exposure settings above and below (that is, bracketing) the presumed correct setting.

Cast
An overall tinge of a particular color in a print or transparency. Color casts often occur when the light source illuminating the subject of a photograph is not matched to the film.

Color negative (print) film
Film processed as a negative image from which positive prints can be made.

Color transparency (slide) film
Film giving direct color positives in the form of transparencies. It is also known as reversal film.

Color temperature
Term describing the color quality (particularly the redness or blueness) of the light source.

Complementary colors
Two contrasting colors that produce an achromatic shade, white, gray or black, when mixed. Complementary color pairs are important in colour films and printing processes. Traditionally, the pairs used are red-cyan, green-magenta and blue-yellow.

Daylight film
Film balanced to give accurate colors when exposed to a subject lit by daylight or light of similar color-temperature – for example, electronic flash.

Depth of field
The zone of acceptable sharp focus in a picture, extending in front of and behind the plane of the subject that is most precisely focused by the lens.

Exposure
The total amount of light allowed to pass through a lens to the film, as controlled by both aperture size and shutter speed. The exposure selected must be tailored to the film's sensitivity to light, indicated by the film speed rating. Hence overexposure means that too much light has created a slide or print that is too pale. Conversely, underexposure means that too little light has resulted in a dark image.

Film speed
A film's sensitivity to light, rated numerically so that it can be matched to the camera's exposure controls. The two most commonly used scales, ASA (American Standards Association) and DIN (Deutsche Industrie Norm), are now superseded by a new system known as ISO (International Standards Organization), which amalgamates the ASA and DIN ratings.

Filter
A glass, plastic or gelatin screen placed in front of the lens to alter the appearance of the image. Color filters work by absorbing selected wavelengths of light.

Flash
A very brief but intense burst of artificial light, used in photography as a supplement or alternative to any existing light in a scene.

Fluorescent light see VAPOR LAMP

Focal length
The distance, usually given in millimeters, between the optical center of a lens and the point at which rays of light from objects at infinity are brought to focus. In general, the greater the focal length of a lens, the smaller and more magnified the part of the scene it includes in the picture frame.

Graduated filter
A filter in which a clear and colored half gradually blend into each other. A graduated filter can be used, for example, to enliven a dull sky in a landscape without affecting the rest of the image.

Grain
The granular texture appearing to some degree in all processed photographic materials. In black-and-white photographs the grains are minute particles of black metallic silver that constitute the dark areas of a photograph. In color photographs the silver is removed chemically, but tiny blotches of dye retain the appearance of the grain. The more sensitive – or fast – the film, the coarser the grain will be.

Latitude
The ability of a film to record an image satisfactorily if exposure is not exactly correct. Black-and-white and color print films generally have more latitude than color transparency films.

Polarizing filter
A filter that changes the vibration pattern of the light passing through it, used chiefly to remove unwanted reflections from a photographic image or to darken the blue of the sky.

Primary colors
Blue, green and red – the colors of light that when mixed together equally make white light, and that, when mixed in various combinations, can make any other color. Saturated colors are "pure" colors that reflect only one or two primaries – when a third primary is introduced the color is "de-saturated" toward white, gray or black.

Saturated color see PRIMARY COLOR

Shutter
The camera mechanism that controls the duration of the exposure.

Stop
A comparative measure of exposure. Each standard change of the shutter speed or aperture (for example, from 1/60 to 1/125 or from f/2.8 to f/4) represents a stop, and doubles or halves the light reaching the film. On some cameras you can make settings in between the standard marks – usually in half-stops.

Tripod
A three-legged camera support. The legs (usually collapsible) are hinged together at one end to a head to which the camera is attached.

Tungsten light
A very common type of electric light for both domestic and photographic purposes – named after the filament of the metal tungsten through which the current passes. Tungsten light is much warmer (more orange) than daylight or electronic flash, and you must use a filter with daylight-balanced color film to compensate for this if you want to reproduce colors accurately. Alternatively, use tungsten-balanced slide film.

Ultraviolet
A form of electromagnetic radiation close in wavelength to light. UV radiation is invisible to the human eye, but can affect film, sometimes causing a blue cast unless removed by a filter.

Vapor lamp
A lamp containing a gas or vapor that glows with light when an electric current passes through it. Mercury, neon and sodium vapor lamps produce strongly colored light, but the light from fluorescent tubes approximates more closely to daylight.

Index

Acknowledgments

Picture Credits

Abbreviations used are: t top; c center; b bottom; l left; r right.
Michael Freeman, the consultant photographer for this volume, is abbreviated as MF, John Garrett as JG and Image Bank as IB.

Cover Peter Van Rhjin/Four by Five Agency Inc.

Title David Fairman. **7** Graeme Harris. **8-9** JG. **10** Ian Miles/IB. **10-11** JG. **12** Franco Fontana/IB. **13** Linda Burgess. **14-15** Robert Farber/IB. **15** John Sims. **16-17** Leo Mason. **18-19** Noble Beheler. **20** Paul Brierley. **21** MF. **22** MF. **23** tl tr bc MF, ct Ashvin Gatha, bl Sally & Richard Greenhill, br Jerry Young. **24** Roger Payling. **25** MF. **26** Linda Burgess. **27** tr Graeme Harris, l John Starr. **28** bl br Colin Molyneux/IB. **29** tl tr Linda Burgess, bl br Colin Molyneux/IB. **30** F C Gundlach/IB. **31** Peter Gittoes. **32** JG. **33** tl tr cl cr br JG, c Mari Mahr, bl Andrew Parkhouse. **34-35** Franco Fontana/IB. **36** Pete Turner/IB. **37** John Sims. **38** Mike Burgess. **39** t Cyril Isy-Schwart/IB, b Simon Yeo. **40-41** Vautier/de Nanxe. **41** t Vautier/de Nanxe, b Robin Laurance. **42** Ashvin Gatha. **42-43** Robin Laurance. **44** tr Brian Seed/Click/Chicago, bl Vautier/de Nanxe. **45** t Brian Seed/Click/Chicago, b Ashvin Gatha. **46** Linda Burgess. **47** t Pete Turner/IB, b Marcel Nauer. **48** tr Linda Burgess, b Ashvin Gatha. **49** Kate Salway. **50** David Parker. **51** t Linda Burgess, b Ashvin Gatha. **52** tr Jerry Young, b Peter Gittoes. **53** Robin Laurance. **54** tr Neill Menneer, bl Ashvin Gatha. **54-55** Franco Fontana/IB. **56-57** John Hedgecoe. **58** Pete Turner/IB. **58-59** Ashvin Gatha. **60** Graeme Harris. **61** t Linda Burgess, b Lisl Dennis/IB. **62** bl Walter Iooss/IB, cr JG. **63** Cecil Jospé. **64** Michelle Garrett. **65** t JG, b Linda Burgess. **66** MF. **67** Michael Borum/IB. **68** Alain Choisnet/IB. **69** tl Ian Bradshaw, tr Max Hess, b MF. **70** l MF, r Bill Plummer/IB. **71** Max Hess. **72** l Grafton Marshall Smith/IB, r G Palmer/IB. **73** t Franco Fontana/IB, b Frantz Thionville/Kodak. **74** tl Vautier/de Nanxe, tr Larry Dale Gordon/IB, b Wal R Gyr. **75** Ian McKinnell. **76** l Michelle Garrett, r JG. **77** t JG, b Niki Mareschal/IB. **78** l Donald E Carroll/IB, r Ellis Herwig/IB. **79** t Gerard Champlong/IB, b Vautier/de Nanxe. **80** Eberhard Grames. **80-81** Arthur D Arazien/IB. **82** tl Robin Laurance, tc Graeme Harris, tr André Chastel/Kodak, b John Hedgecoe. **83** Pete Turner/IB. **84-85** Dennis Stock/Magnum. **86** t Ian McKinnell, b John Sims. **87** Michel Casino/IB. **88** t Walter Rawlings, b Ernst Haas/Magnum. **88-89** G M Smith/IB. **90** Ian McKinnell. **91** J P Lescourret/fotogram. **92** Julian Calder. **92-93** Nadia Mackenzie. **94** t Franco Fontana/IB, bl Ian McKinnell, br MF. **95** Franco Fontana/IB. **96** l JG, c Geoff Nobes/Press-Tige Pictures, r MF. **97** Linda Burgess. **98** Pete Turner/IB. **99** Alain Choisnet/IB. **100** Jacques Alexandre/IB. **101** t Ralf Schutt, b John Sims.

Artists Kuo Kang Chen, Roy Flooks, Alan Suttie

Kodak, Ektachrome, Kodachrome and Kodacolor are trademarks

Time-Life Books Inc. offers a wide range of fine recordings, including a *Big Bands* series. For subscription information, call 1-800-621-7026, or write TIME-LIFE MUSIC, Time & Life Building, Chicago, Illinois 60611.

Notice: all readers should note that any production process mentioned in this publication, particularly involving chemicals and chemical processes, should be carried out strictly in accordance to the manufacturer's instructions.